The
GOLDEN GATE

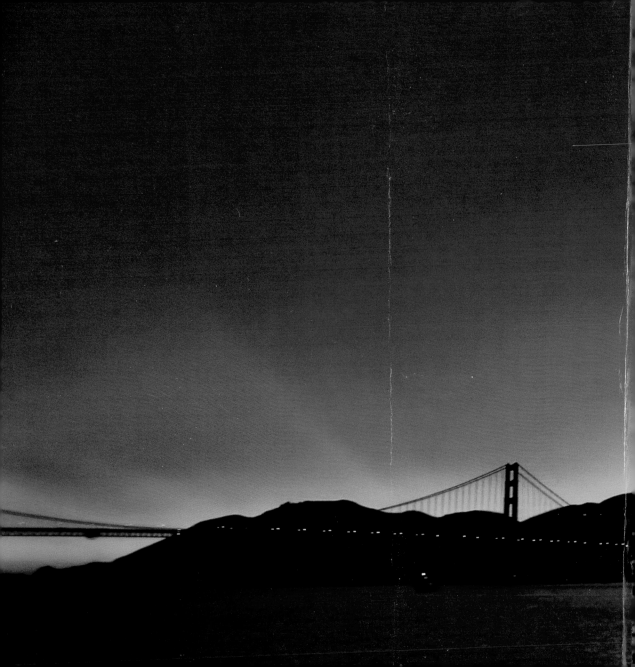

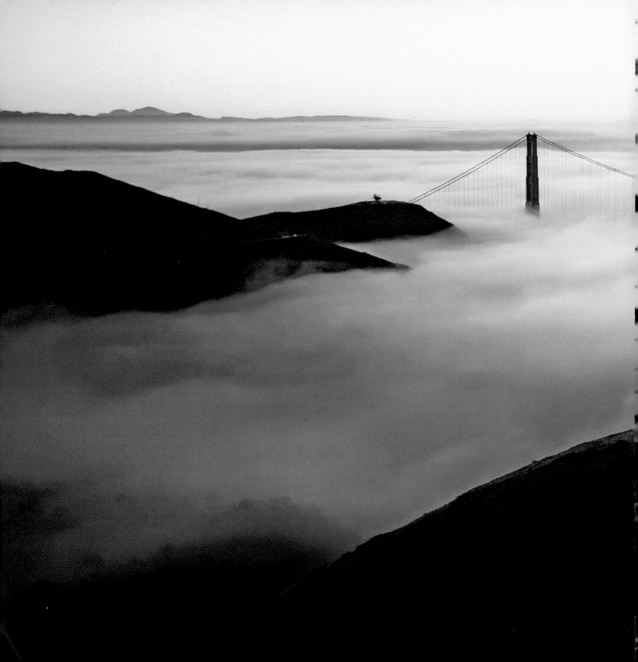

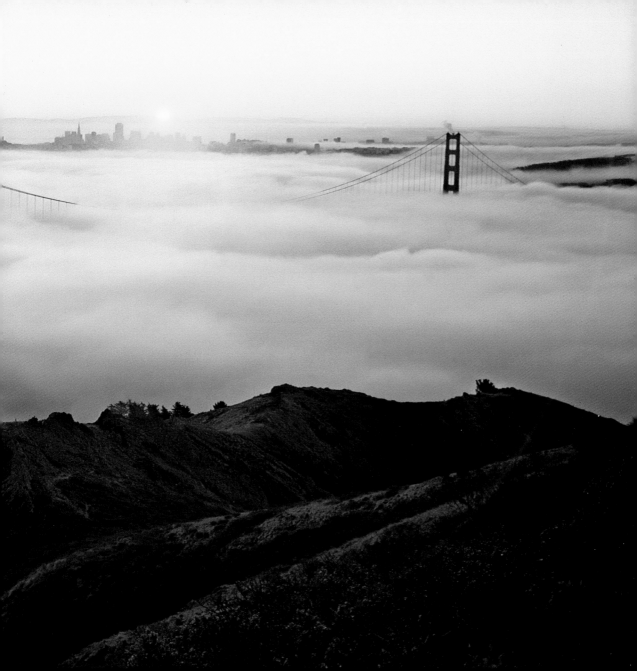

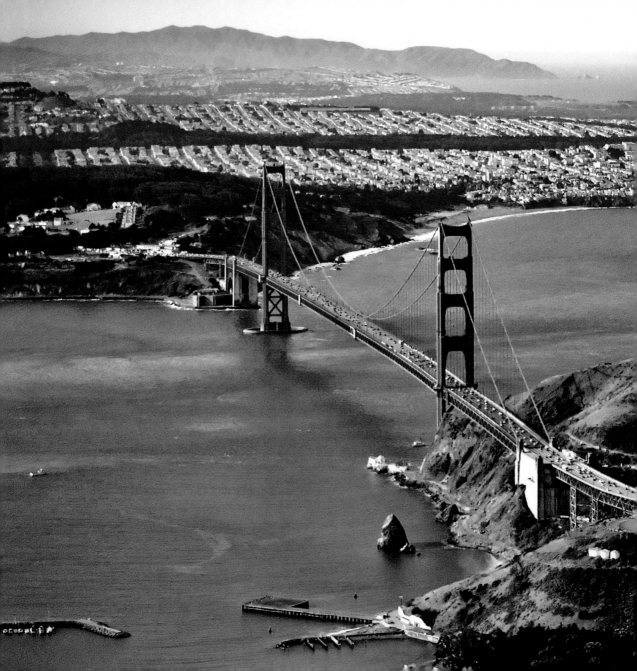

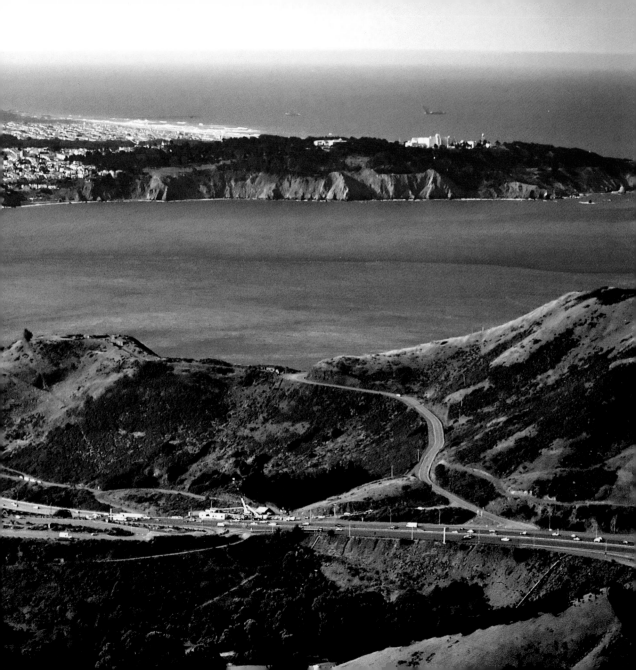

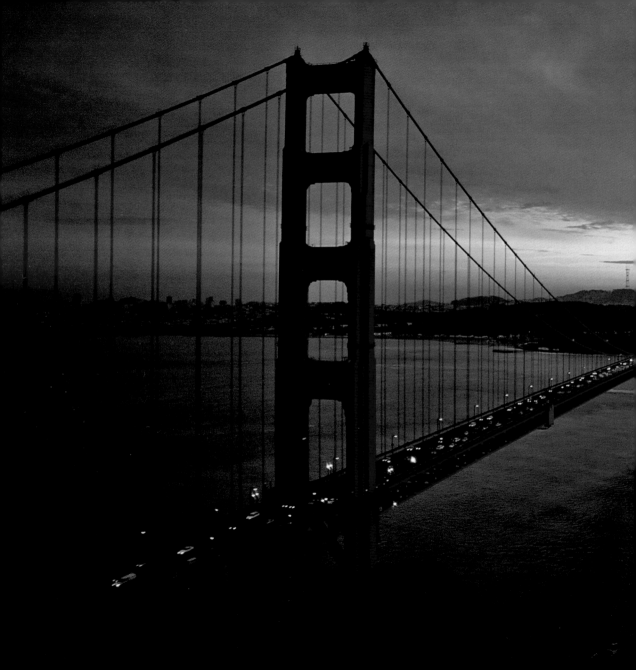

The GOLDEN GATE

SAN FRANCISCO'S CELEBRATED BRIDGE

Edited by PETER BEREN

Photography by MORTON BEEBE

EARTH AWARE
EDITIONS

San Rafael, California

EARTH AWARE
EDITIONS

PO Box 3088
San Rafael, CA 94912
www.earthawareeditions.com

Design by Dagmar Trojanek

ROOTS of PEACE REPLANTED PAPER

Insight Editions, in association with Roots of Peace, will plant two trees for each tree used in the manufacturing of this book. Roots of Peace is an internationally renowned humanitarian organization dedicated to eradicating land mines worldwide and converting war-torn lands into productive farms and wildlife habitats. Together, we will plant two million fruit and nut trees in Afghanistan and provide farmers there with the skills and support necessary for sustainable land use.

Manufactured in China by Insight Editions

10 9 8 7 6 5 4 3 2 1

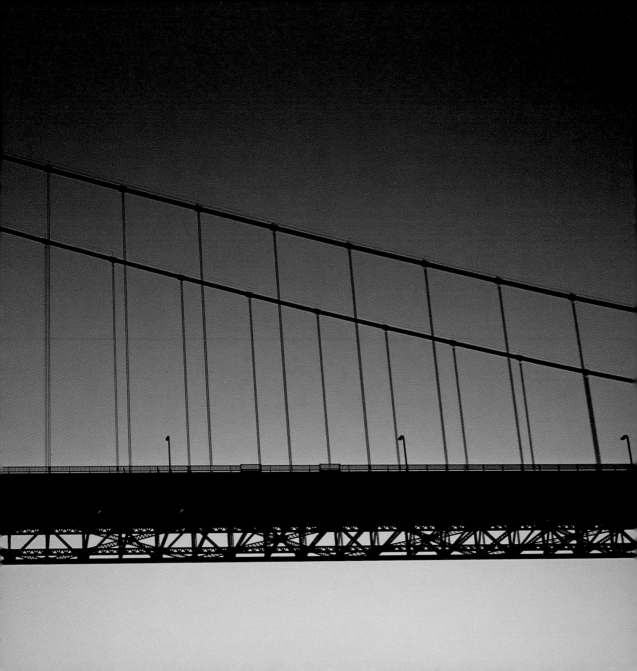

CONTENTS

INTRODUCTION 15

THE BRIDGE 27

SELECTED BIBLIOGRAPHY 127

ACKNOWLEDGMENTS 128

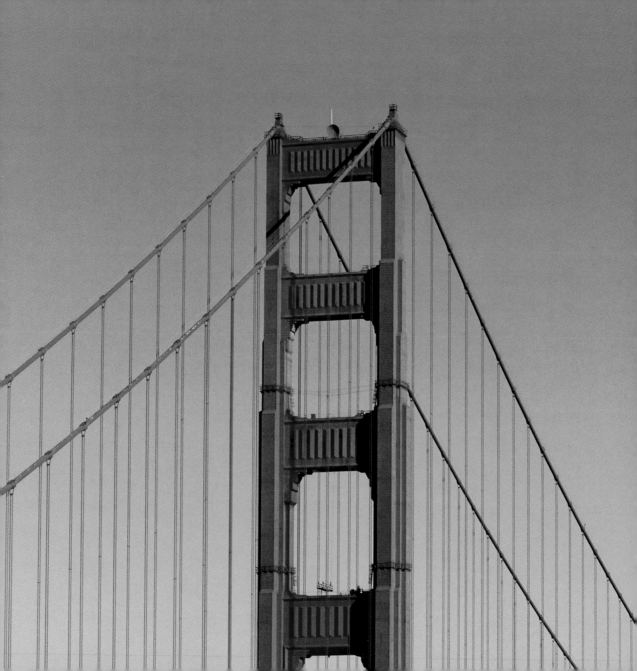

INTRODUCTION

IN MANY WAYS, THE GOLDEN GATE BRIDGE IS

ABOUT DREAMS—IN PARTICULAR, DREAMS OF SAN

FRANCISCO AND THE FUTURE OF CALIFORNIA.

Certainly, it was imagined long before it was realized. Legend

attributes its inspiration to a celebrated San Francisco eccen-

tric, "Emperor Norton," who in 1869 issued a proclamation

calling for a bridge across the stunning divide between the San

Francisco Bay and the Pacific Ocean. Los Angeles was growing

fast and threatening San Francisco's position as the premier city

in California, and it was thought that bridging the Golden Gate

would restore some of San Francisco's former glory. Some even

thought the Bridge could put San Francisco back on the world

stage, as it had been during its founding in the Gold Rush.

However, the real impetus for the landmark span came from boosters and businessmen who hoped to promote economic development and growth in Northern California in the age of the automobile. The Redwood Highway Association, an odd assemblage of nature enthusiasts and agriculturalists who shared a vision for the region, was formed in 1920 to address the patchy, primitive roads that were plagued by sand and mud. They envisioned a paved highway running from Marin County, just north of San Francisco, all the way into Oregon, a route that would open up the region's forests, beaches, and rolling hills to tourists, sightseers, and new residents.

It wasn't long before association members realized that the key to the future of Northern California wasn't pavement. Before paved roads would make any significant difference, they had to make that final, vital connection to the region's center of wealth and power: San Francisco. A bridge between the City and Marin County would be the most important mile of the Redwood Highway, making the dream of a "Redwood Empire" a true possibility.

Frank P. Doyle, a leader in the Santa Rosa business community, called the first meeting to discuss a Golden Gate Bridge in 1923. Next the group teamed up with San Francisco city engineer M. M. O'Shaughnessy, who had already taken the initiative to commission a preliminary design from Chicago engineer Joseph B. Strauss. While the idea of the Bridge navigated the political process, Strauss began to refine his original design until 1930, when it assumed the familiar shape that we know today. Strauss was blessed to be working with some of the finest engineering consultants in the nation and, ultimately, was able to design a bridge that reigned as the longest suspension bridge in the world for almost three decades.

Financing the Bridge required just as much imagination as designing it. Many large bridges—public and private—were paid for with tolls in the early twentieth century, which meant that people needed to cross them frequently. But the commu-

nities north of San Francisco were small, few, and far between. In order to generate enough traffic to pay for the span, the region would have to attract legions of new commuters, as well as a steady stream of tourists. The Bridge's promoters envisioned vast stretches of thriving suburbs, summer homes, and resorts along the gorgeous shores and mountains of Northern California to attract the numbers needed. But no private investors were willing to gamble on such a dream. So the Bridge became a public project, well before the New Deal and federal

BELOW *The Golden Gate Bridge under construction in June of 1935.*

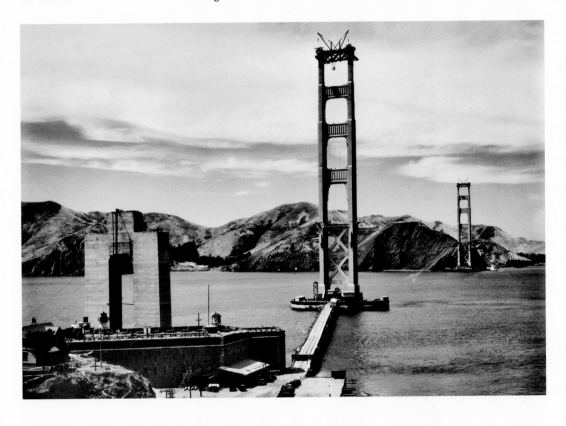

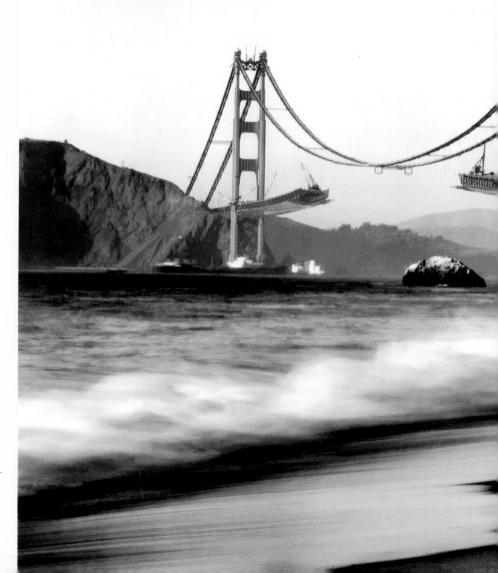

RIGHT *The Bridge in progress, October, 1936.*

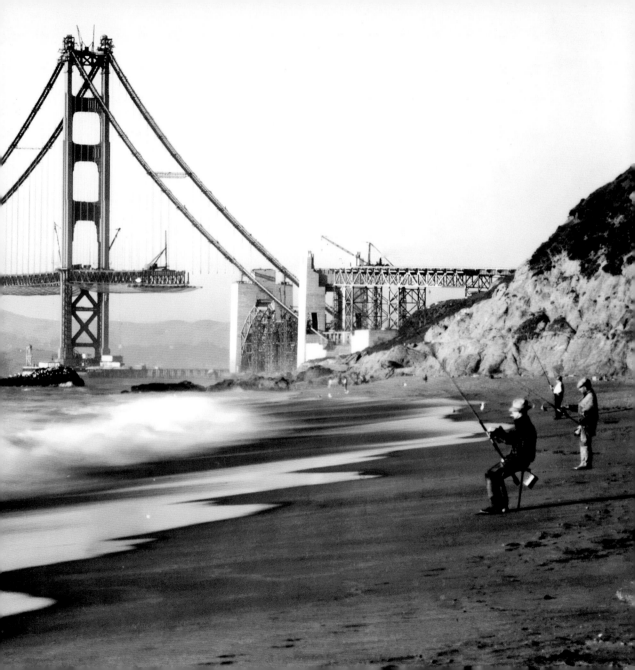

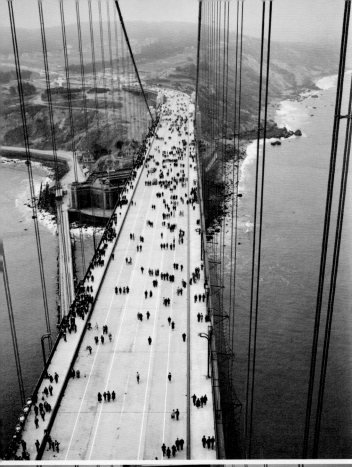

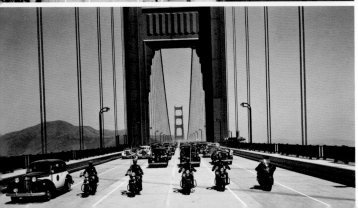

funding made large-scale government-sponsored construction commonplace. San Francisco and the five counties to the north of it banded together in 1925, pledging to pay for the Bridge with property taxes if toll revenue fell short.

A long legal and political battle followed, but the bridge boosters ultimately won authorization to create a new government agency to finance, build, and manage a new bridge. The Golden Gate Bridge and Highway District was incorporated in 1928. Two years later, bridge bonds won public approval in a landslide vote. While the span was still considered risky, the crash of 1929 and the onset of the Great Depression made the promise of jobs enough to convince the citizens of Northern California to take on the risk of building the Golden Gate Bridge.

The delay in getting the Bridge approved turned out to be fortuitous, having allowed time for some critical advances in bridge engineering and specifically in the construction of long, lightweight suspension spans. Winning the job of Chief Engineer, Joseph Strauss,

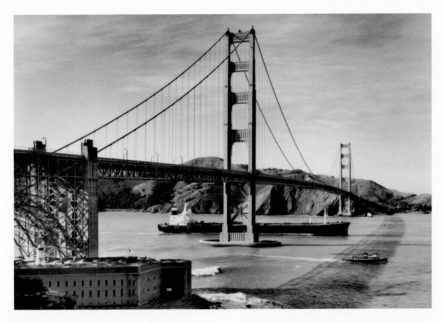

who had been one of the Bridge's most persistent promoters, assembled a talented team that produced a spectacularly beautiful and technically innovative design, applying the engineering expertise of Charles Ellis and the architectural genius of Irving Morris. In the midst of a lean national economy, these men proposed a spare and elegant bridge.

The graceful structure arose from a rocky, deep chasm that had been carved over millennia by steady and swift currents surging into the Pacific Ocean. The Bridge's cement foundations had to be set more than 300 feet underwater, where they were protected by vast caissons. Its scale—with over 4,000 feet of roadbed between the piers—was unprecedented for a suspension span. Purchasing the immense amount of cement and steel required for its construction stimulated a struggling national economy. More

importantly, building the Bridge and the new streets and highways it would be connected to provided years of work for skilled and unskilled laborers from all over Northern California. Newspapers covered the Bridge's progress in detail with weekly reports, quickly turning it into a symbol of national progress and prosperity.

A variety of ceremonies marked the opening of the Golden Gate Bridge, but the most symbolic was the presentation of the final rivet. On May 27, 1937, a sixteen-ounce gold rivet donated by the State Chamber of Commerce was hammered into place, immediately disintegrating under the immense pressure. Spectators were showered with gold dust as chunks of precious metal fell into the water below.

While wartime shortages and rationing limited traffic on the new Golden Gate Bridge, it became immensely profitable when veterans returned home. Managing toll revenue that exceeded even the most optimistic predictions of the Bridge's promoters, the agency

responsible for managing the Bridge quickly gained notoriety for extravagance and waste. Soon, the biggest worry of Golden Gate Bridge and Highway District officials was how to manage their burgeoning reserve funds and surplus revenues.

As the population surged, automobile ownership increased exponentially. Soon, crowded commuters began to demand toll reductions, leading to charges of waste and mismanagement that generated a series of investigations. Bridge leaders fought to protect their privileges and the financial security of their agency. Rather than lower tolls, they began to spend large sums of money on lobbying and public relations to counter their critics. Bills to dissolve the district were introduced in every California state legislative session from the 1940s through the 1960s, but all reform efforts failed.

Traffic increased steadily in the 1960s, and soon, the Bridge became a bottleneck. Ironically, the span that was intended to promote growth in North-

OPPOSITE *The Bridge, seen from San Francisco's Pacific shore.*

ern California became an obstacle to development. And yet, proposals to add a second deck or commuter train to the Bridge failed. Some would say this is because voters were moved by beauty and did not want to mar the perfect profile of their world-class bridge.

In the 1970s, the Golden Gate Bridge, Highway, and Transportation District chose to approach the region's growing traffic problems in a dramatically different fashion, transforming the organization from a bastion of privilege into a lean regional transportation agency. A new generation of bridge leaders took the helm, rethinking the purpose of the Bridge. They knew that the last of the construction debt would be retired in 1972, and they saw an opportunity to invest the millions in reserve funds that had accumulated over the years. Among these reformers was Stephen Leonoudakis, who became known as a "the admiral." He urged his colleagues to take action, and they did. The Golden Gate Bridge, Highway, and Transportation District released

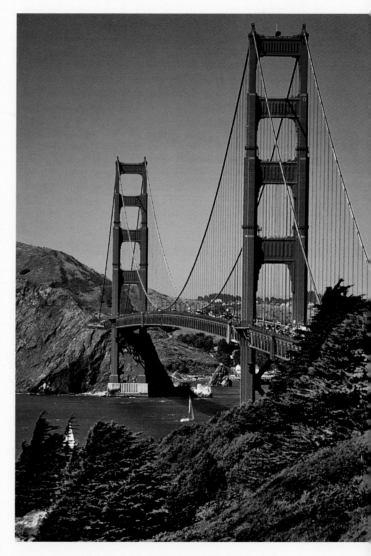

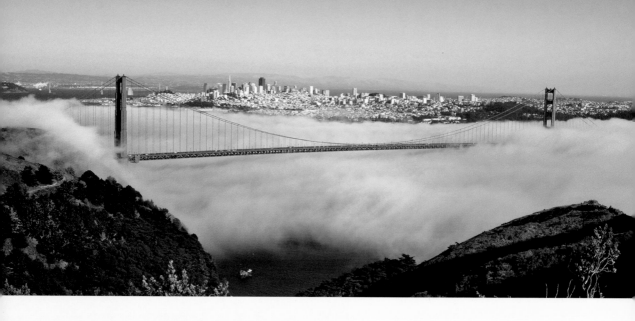

monies to establish new ferry and bus systems, reducing traffic and providing much-needed mass transportation to the still-growing suburban counties north of San Francisco. Toll revenues began to support congestion relief as well as bridge maintenance and operations. The Bridge was no longer just a means of crossing the Bay—it was a resource and symbol for leadership in solving regional problems.

On a deeper level, the Bridge began to accrue layers of meaning, just as San Francisco has throughout its history.

Underneath the practical concerns and dreams of economic prosperity was a tapestry of associations that went to the very soul of San Francisco, "the City that was never a village." San Francisco was born in the Gold Rush and almost instantaneously became a world city—one built on golden dreams. This "golden gateway" captured the mystique of San Francisco, which shimmers like a vision on the other side of the structure.

As much a symbol as it was in the 1930s, when it stood for economic well-being, the Golden Gate Bridge today is

a powerful icon and source of identity for the Bay Area. Successful in promoting prosperity and growth in Northern California when first constructed, today it supports the region as the cornerstone of the area's public transportation infrastructure and serves as a powerful attraction for the thousands of tourists and sightseers who visit the City on an annual basis. Erected during an era of optimism, cooperation, and hope, today the Bridge remains a symbol of an almost utopian sense of community, as well as a source of pride for residents of the Bay Area.

When you enter the roadway of the Bridge from the Marin side, you are immediately struck by a feeling of expansiveness, as if space and time were opening up and each tower was a portal into another world. This feeling, along with the impressive views of San Francisco and the vastness of the Pacific Ocean, have made the Bridge the best example of the San Francisco tradition of using science and human ingenuity to alter the land while also showing reverence for it. No one can say that the Golden Gate Bridge is a structure that mars the natural beauty that surrounds it. Rather, this triumph of design and engineering enhances the landscape it belongs to. And in this sense, it is like the materialization of a dream—a true marvel.

Like Heraclitus stepping into the river, Morton Beebe never photographs the same Bridge twice. In these pages, his lens reveals the many moods and diverse aspects of the Bridge and its environs. Complementing Morton's photography are historical quotations that demonstrate the Bridge's lively history and permanent place in the hearts of San Francisco Bay Area residents and tourists from around the world.

—*Peter Beren, editor*

THE BRIDGE

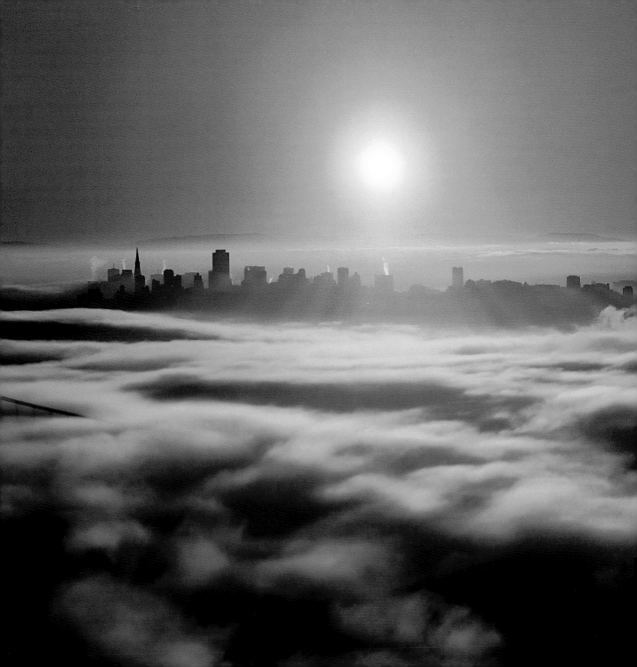

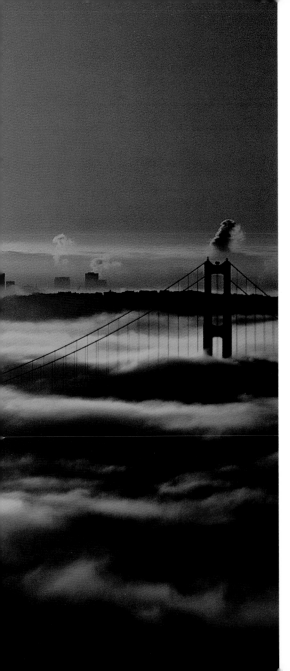

Caught up in the exuberance of the Roaring Twenties, this editorial contends that a bridge across the entrance to the Bay would restore to San Francisco the stature it enjoyed in the mid-nineteenth century. The whole world knew the "Golden Gate" as the entrance to the San Francisco Bay and the life-changing possibilities of the Gold Rush.

"[A] perpetual monument that will make

this city's name ring around the world

and renew the magical fame which the

Golden Gate enjoyed in the days of '49."

—EDITORIAL

San Francisco Examiner, March 24, 1925

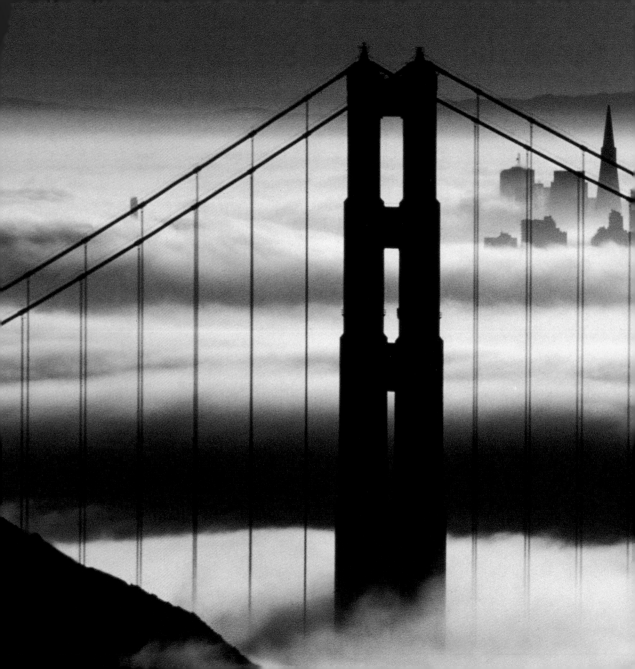

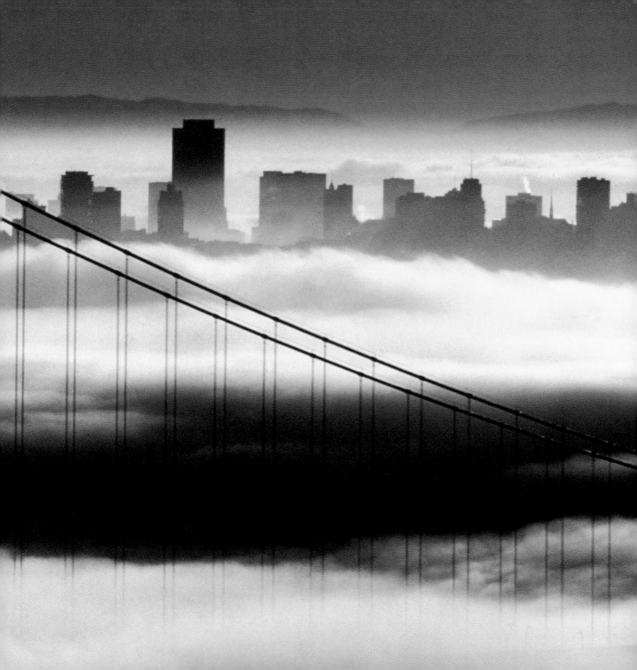

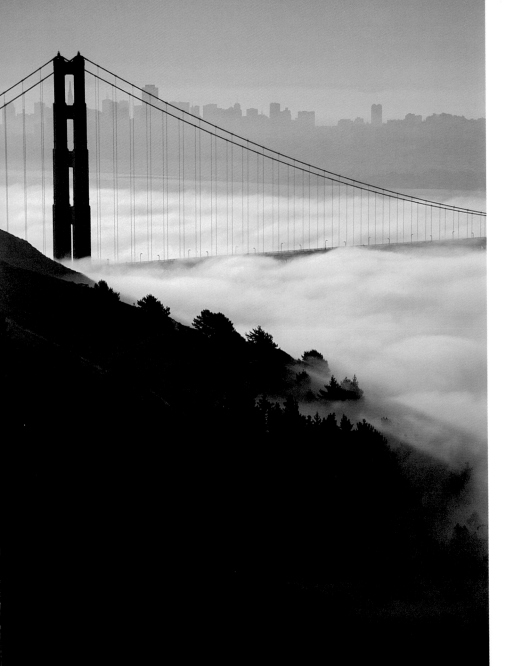

"Our world of today . . . revolves completely around things which at one time couldn't be done because they were supposedly beyond the limits of human endeavor. Don't be afraid to dream!"

—JOSEPH STRAUSS, Chief Engineer

"A GREAT CITY WITH WATER BARRIERS

AND NO BRIDGES IS LIKE A SKYSCRAPER

WITH NO ELEVATORS . . . BRIDGES ARE

A MONUMENT TO PROGRESS."

—JOSEPH STRAUSS, Chief Engineer
in radio interview in 1930

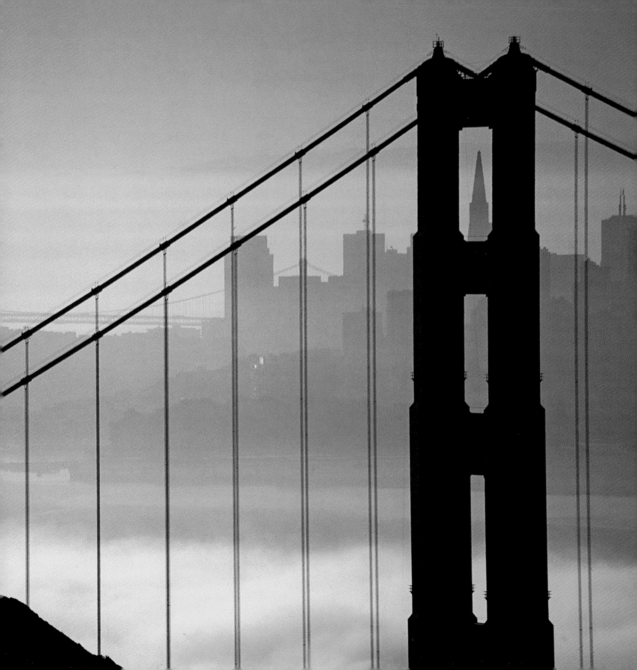

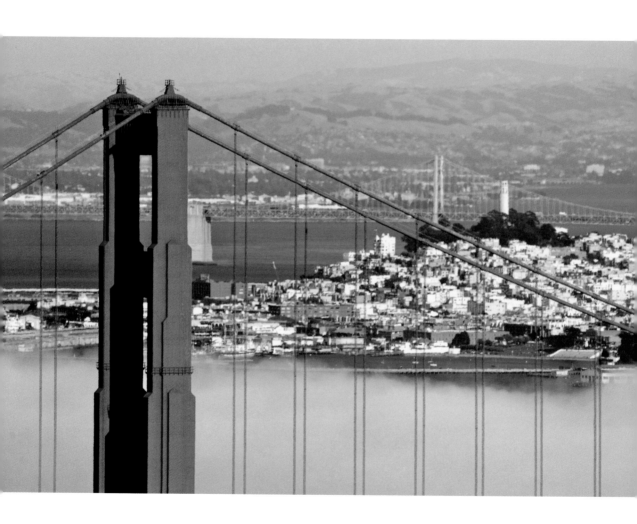

Thanks to the bridge that spans the Golden Gate,
San Francisco has been seen as a city of mythic
proportions—the heir to Byzantium, Constantinople,
and Atlantis; a vision glimpsed in a dream.

"And, finally, the bridge would have to be beautiful,

very beautiful, to be worthy of the beauty

of the Marin Headlands, of the Pacific, and the pastel Atlantis

rising on the shore of the Bay."

· ◗ ◗ ◗ ·

—KEVIN STARR
Golden Gate: The Life and Times of America's
Greatest Bridge, 2010

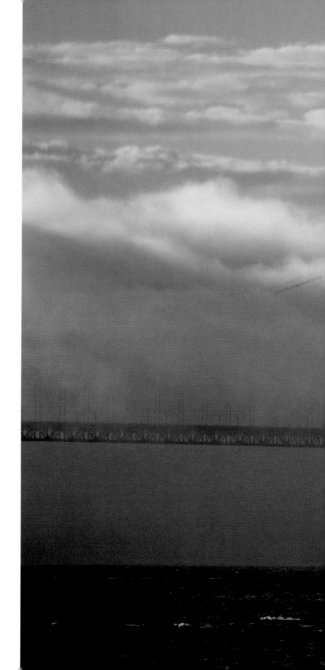

San Francisco was the actual and spiritual home of the Beats. In fact, *San Francisco Chronicle* columnist Herb Caen, "Mr. San Francisco," coined the term "Beatnik."

"I took a bus and rode out over

the Golden Gate Bridge to Marin City.

The sun was making a terrific haze

over the Pacific as we crossed Golden

Gate, a haze I couldn't look into,

and so this was the shining shield

of the China-going world ocean."

—JACK KEROUAC
On the Road: The Original Scroll, 1957

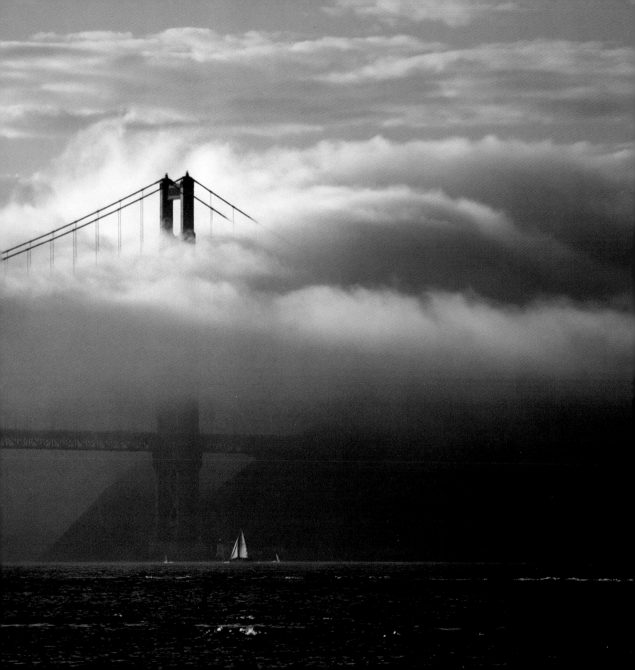

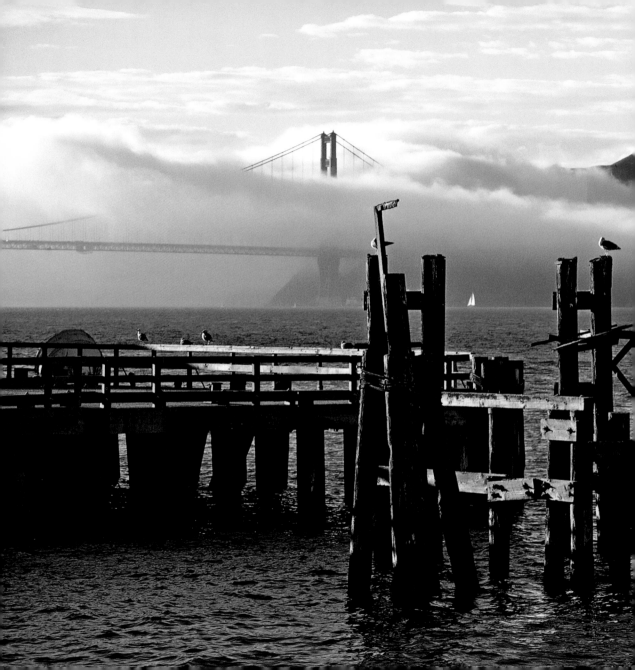

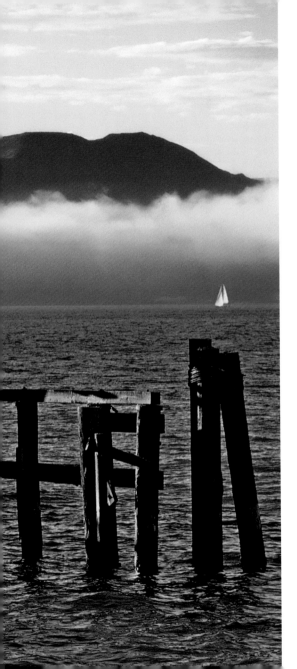

Ironically, the British magazine *Essentially America* published the quintessentially San Franciscan description of the Bridge.

"*The Golden Gate Bridge's daily*

striptease from enveloping

stoles of mist to full frontal glory

is still the most provocative

show in town."

—MARY MOORE MASON

Essentially America, July/August, 2000

Fifteen years after opening day, writers
were still trying to find new ways to
describe the Bridge, dressing it in tropes
of the classical muse.

"I have known her for fifteen years, and

she is more beautiful than ever . . .

Her hair is usually a copper-red, and

she has enormous feet, but once you have seen her

bathing in the sun, she becomes a woman you will

never forget. She is an outdoor girl

who likes to sing when the high winds swirl

past her outstretched arms, and her spirit

and strength are stronger than any storm . . .

Her name is Golden Gate Bridge."

—DEAN JENNINGS
San Francisco Chronicle, July 30, 1952

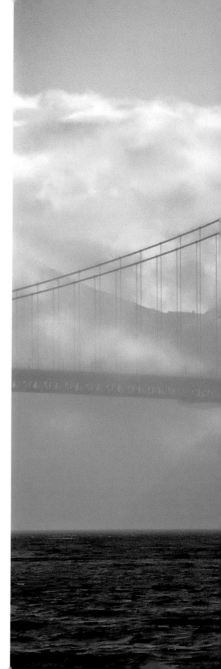

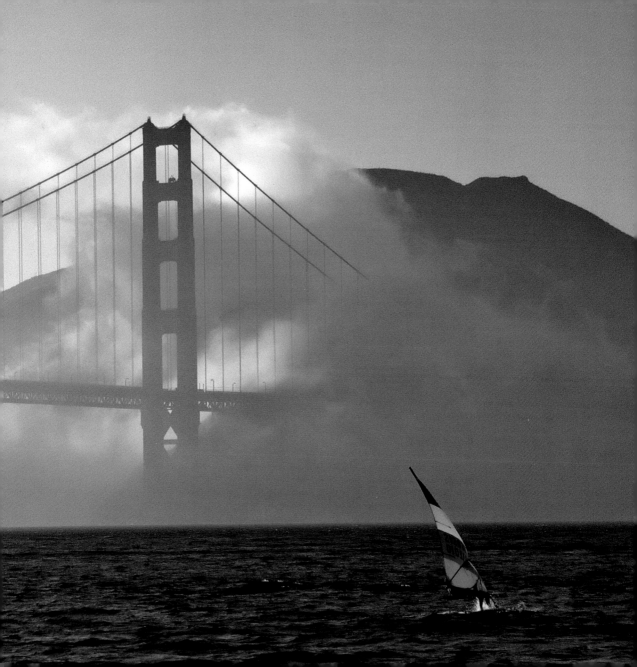

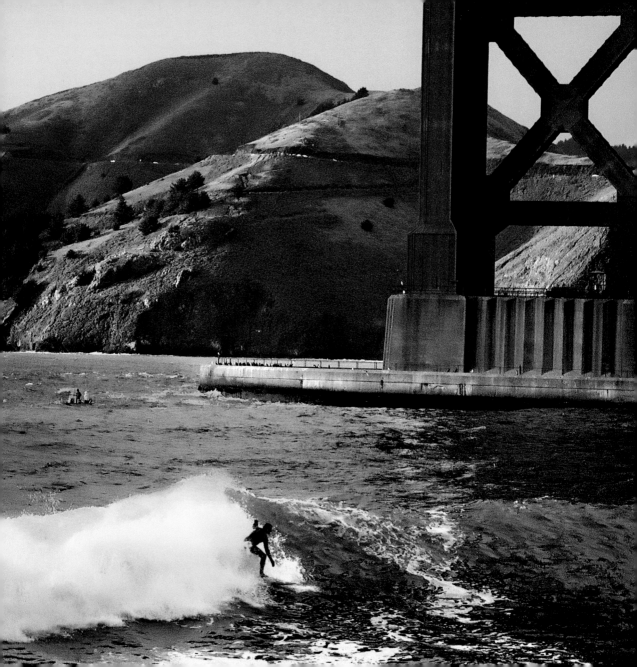

The Chief Engineer first stated, in a newspaper interview,
that the Golden Gate could be bridged, and for
a reasonable sum, in 1917, some twenty years before
the Bridge was built. Here, he looks back on those years
of struggle at the moment of his greatest triumph.

"The Golden Gate Bridge,

the bridge which could not and should not be built,

which the War Department would not permit,

which the rocky foundation of the pier base would not support,

which would have no traffic to justify it,

which would ruin the beauty of the Golden Gate,

which could not be completed within my cost estimate . . .

stands before you in all its majestic splendor,

to the complete frustration

of every attack made upon it."

• ❀ ❀ •

—JOSEPH STRAUSS, Chief Engineer,
speaking at a preopening luncheon
at the Commercial Club, May 6, 1937

John Brown, a returning veteran who fought in the Pacific in World War II, remembers the mere sight of the Golden Gate Bridge as one of the peak experiences of his life.

"One of the thrills of my life was as

our troop ship came into the Golden

Gate, there at San Francisco . . .

[A]s we passed under the Golden Gate

Bridge, somebody said, 'Look up,'

and there bits of the Bridge appeared

through the mist, and we finally realized

we were back in the good old USA."

—JOHN W. BROWN
oral history interview, May 15, 2004

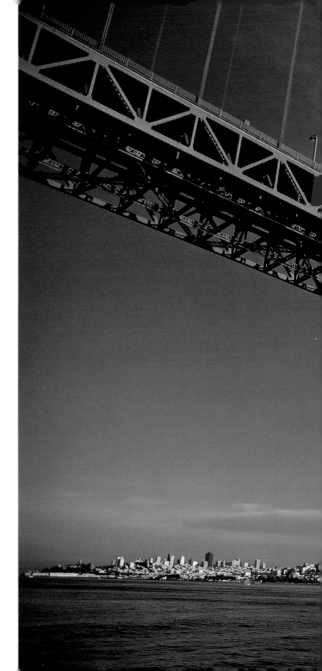

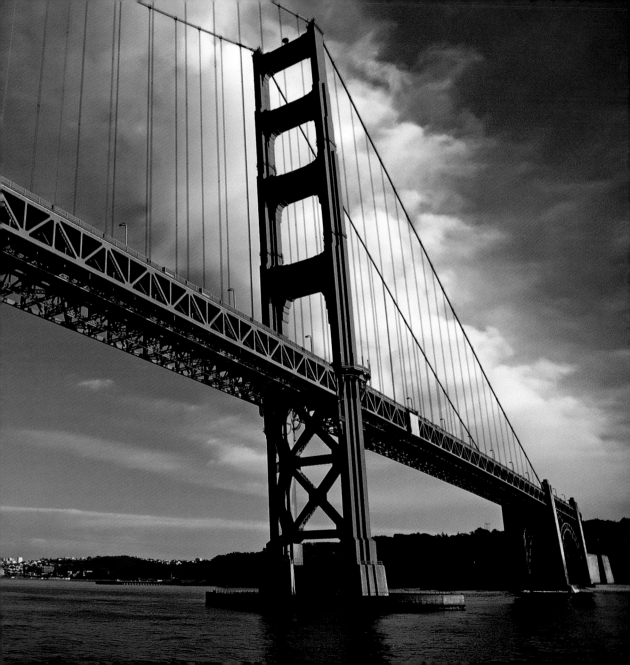

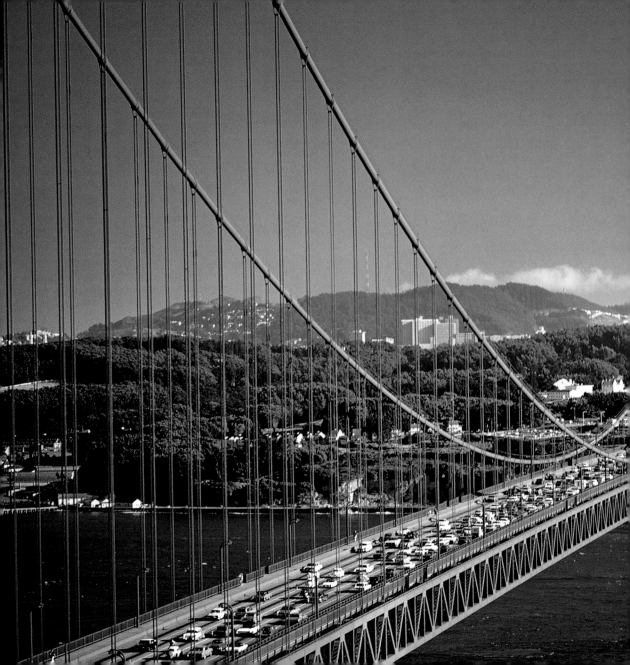

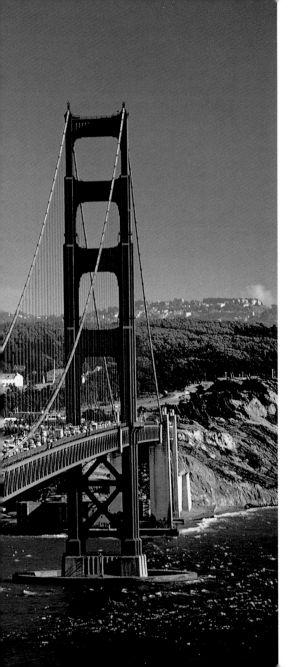

"Traveling across the Bridge is like finding yourself within a prism, witnessing the spectrum. From south to north the traveler curves through the viridian foliage and dark brick buildings of the Presidio to the main span of the Bridge, rust-red despite the name of the paint; over the water (luminous, murky, opalescent, altering by the minute), from which the light seems refracted everywhere; through the electric-blue sky, where white and dusty brown gulls hang suspended like paper birds dangling from strings, tilting, skidding, and slipping in the Pacific wind that whines through the cables; then on down the ramp between the sienna hills of Marin County."

—Evan S. Connell Jr.
Holiday Magazine, April 1961

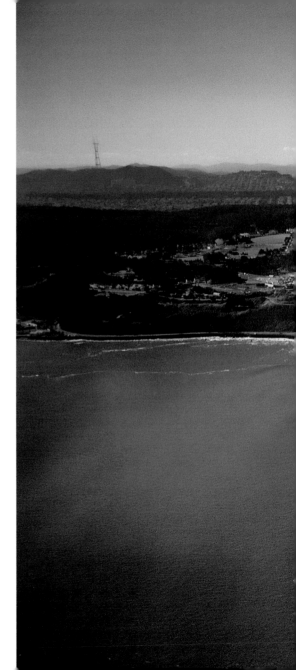

Building the Bridge united the blue-collar workingman and the white-collar businessman, while celebrating community, integrity, and public service. Francis Keesling's speech from the Bridge Dedication Ceremony suggests that bridges were the cathedrals of the Industrial Age.

"From headland to headland, defining the Golden Gate . . . a splendid structure under which the restless waters surge and flow, first in one direction, then in the opposite, stands complete, a terrestrial glory . . . It inspires integrity. It stands as a monument to faithful and efficient public service. It is a tribute to the integrity of the American businessman and to labor and the real champions of labor."

· ✪ ✪ ·

——FRANCIS V. KEESLING, former Bridge Director,
from the address he delivered at the
Golden Gate Bridge Dedication Ceremony
at Crissy Field, May 28, 1937

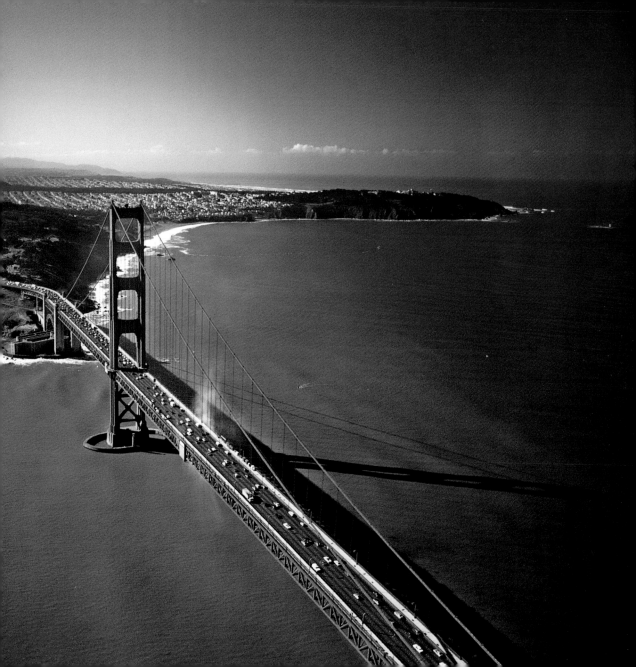

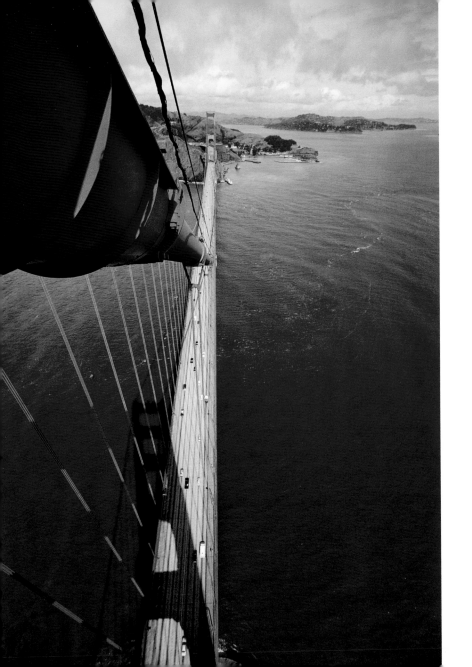

While the Bay Bridge was funded by the federal government, the Golden Gate Bridge was voted in by the electorate, along with a $35 million bond issue. San Franciscans' ability to work together for the common good and to share a common vision harkened back to the Gold Rush days and frontier values, which *San Francisco Chronicle* reporter Willis O'Brien evoked in his commentary on the Bridge's opening day.

"In those crowds, there was a curious feeling of deep-seated pride in that bridge, the pride of the people who had willed it to be ... It is a big thing, that bridge, the biggest in the world, and those people who gathered to claim it were proud that it was [in San Francisco] ... where big things are dreamed and big things are accomplished."

—WILLIS O'BRIEN
San Francisco Chronicle, May 28, 1937

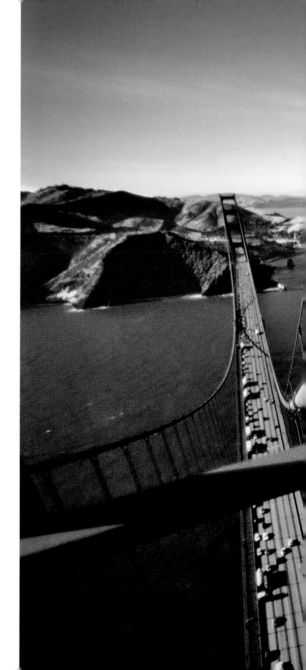

"THE BRIDGE IS A TRIUMPHANT

STRUCTURE, A TESTIMONY TO

THE CREATIVITY OF MANKIND."

—KEVIN STARR

Golden Gate: The Life and Times of America's Greatest Bridge, 2010

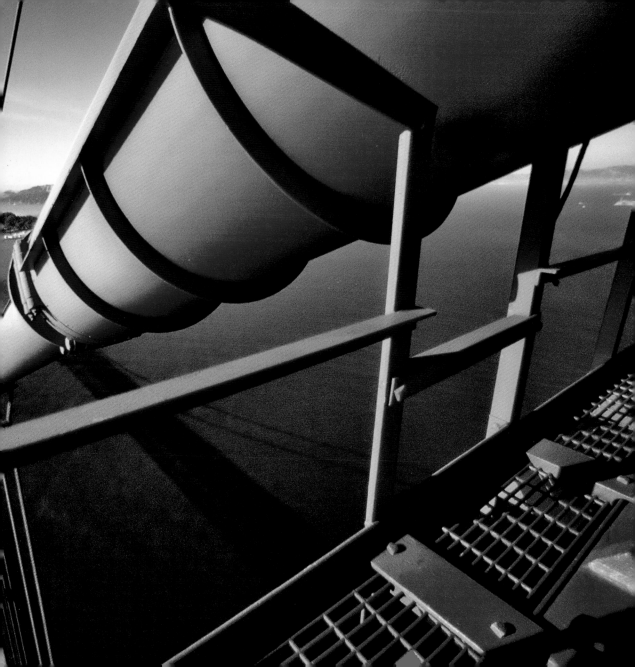

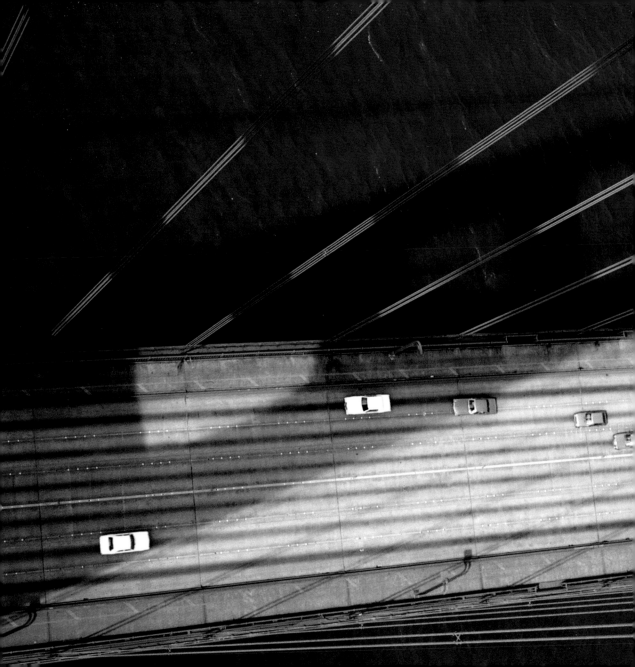

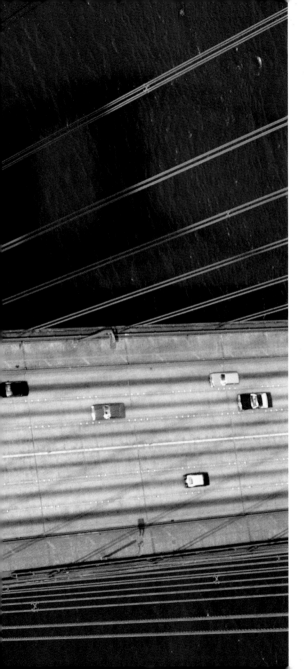

"Over their suspended roadbeds, traffic streams across the racing tides of the Golden Gate to the bluffs and thicket-choked gullies of the Marin shores and across the Bay's wide sweep of gray-green water to the mainland."

—SAN FRANCISCO IN THE 1930S: THE WPA GUIDE TO THE CITY BY THE BAY, 2011

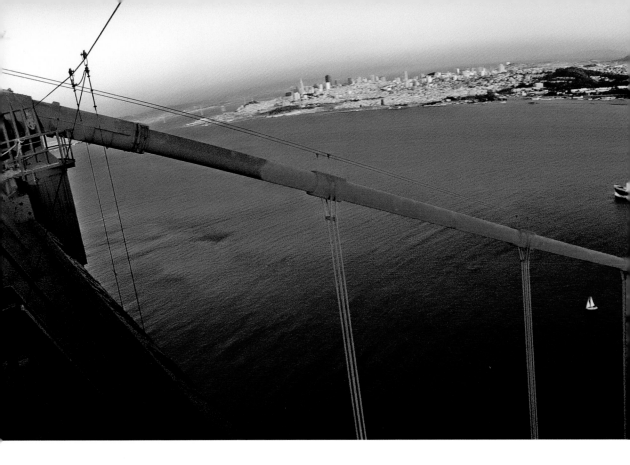

A key concept in selling the idea of bridging the Gate was connecting to the "Redwood Empire," shorthand for the rapidly growing counties north of San Francisco that would allegedly only reach their potential if a bridge was built. Untapped wealth was an appealing idea to Depression-era San Francisco. Such potential also carried the promise of the City outpacing its archrival, Los Angeles.

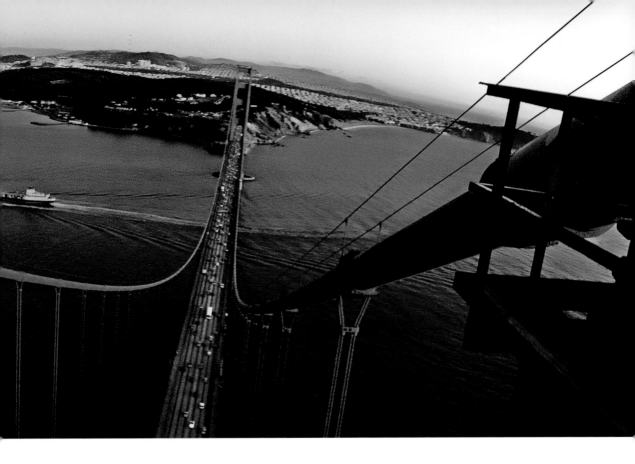

"A means of rapid continuous transportation must be provided, if San Francisco is to keep pace with her sister cities of the West. The Golden Gate Bridge . . . will once and for all time smash the barrier than hems in San Francisco on the north. It will open up the vast hinterland known as the Redwood Empire, furnishing safe and swift transportation to the newest national playground."

—Information Bureau of the Golden Gate Bridge District
"Progress," *San Francisco Chronicle*, November 3, 1930

"See what San Francisco has dared to do! We are building a bridge across our Golden Gate! We are breaking down our walls, we are building a mightier city than you have ever seen. Come and see what we have done! Come and see the happiest, bravest, and most prosperous city in all the world!"

———•———

—EDITORIAL
San Francisco Call Bulletin, November 3, 1930

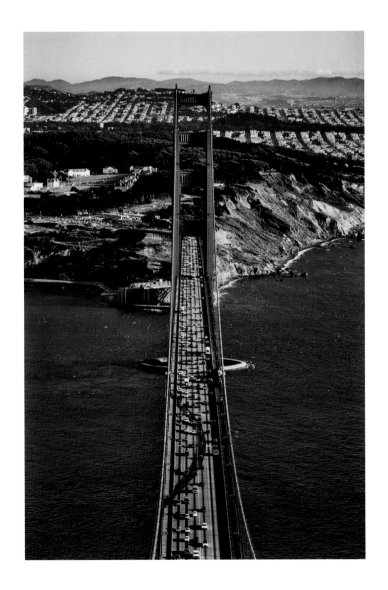

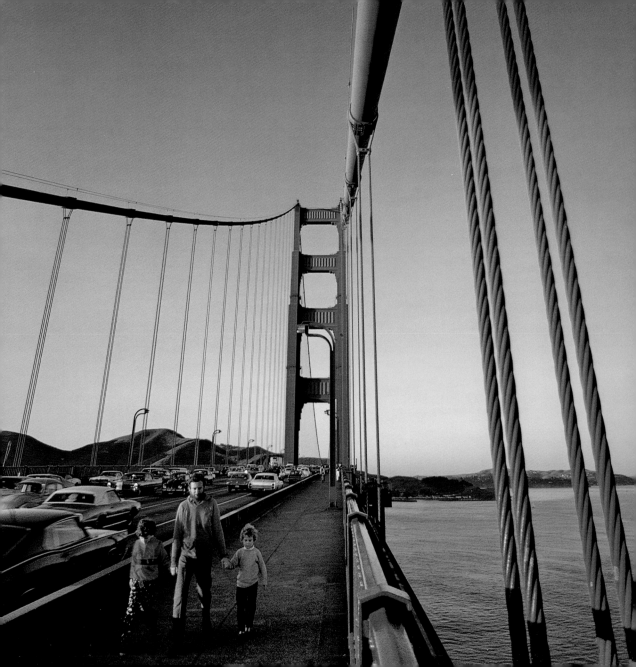

The origin of the name "Golden Gate" goes back to 1846,
when the "Pathfinder," Captain John Frémont, used it in his report
to Congress on his travels through the new territories of the West.

"To this Gate I gave the name of 'Chrysopylae', or Golden Gate, for the same

reason that the harbor of Byzantium was called 'Chrysoceras', or Golden Horn."

—Captain John C. Frémont,
quoted in *San Francisco in the 1930s: The WPA Guide to the City by the Bay*, 2011

The Golden Gate Bridge is painted in a color called International Orange. It is said that by the time a crew finishes putting a new coat, it is time to start all over again.

"[The ten-man paint crew] moved about

the spans the weather allowed painting . . .

in a neverending and unpredictable sequence."

—STEPHEN CASSADY

Spanning the Gate: The Golden Gate Bridge, 1986

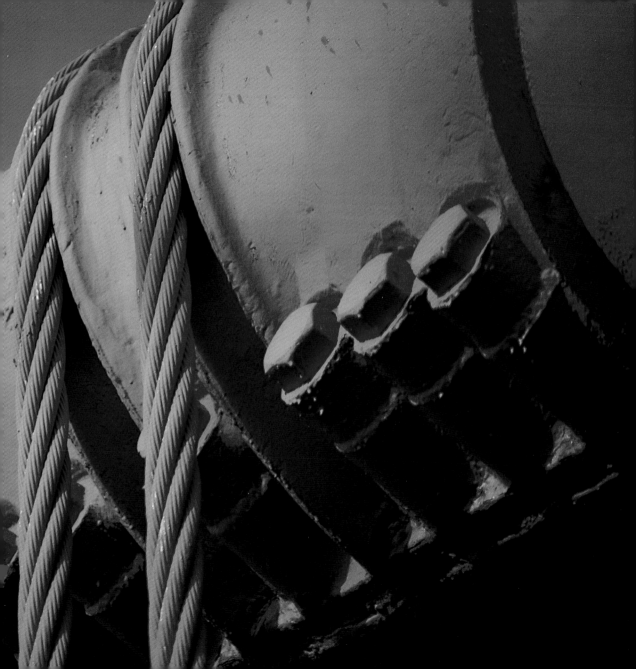

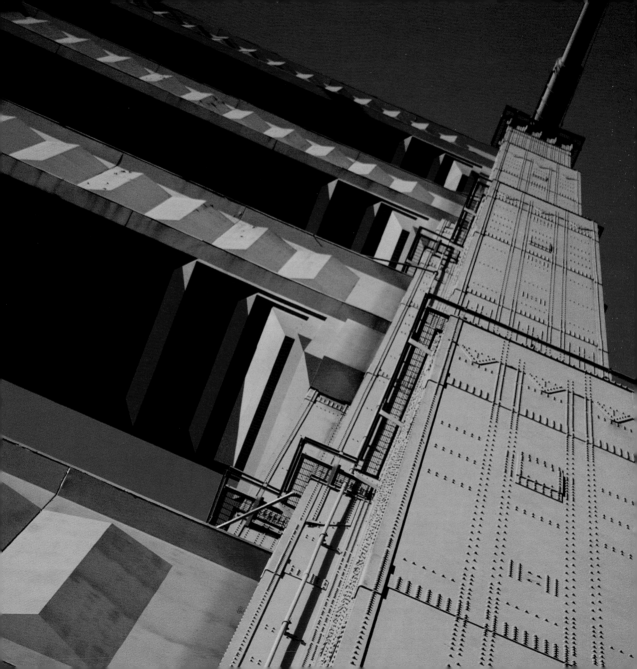

There is a widespread fascination with the statistics
of the Golden Gate, as if the glory and wonder of
the Bridge could be expressed mathematically. Listed
below are the summary figures from the *Almanac
for Thirty-Niners*, a publication produced by the WPA
Federal Writers Project for the Golden Gate International
Exposition of 1939 held on Treasure Island.

80,000 MILES OF WIRE
{enough cable wire to encircle the earth 3 $\frac{1}{2}$ times}

100,000 TONS OF STEEL

254,690 CUBIC YARDS OF CONCRETE

110,000 GALLONS OF PAINT

During Pedestrian Day, when 200,000 people crossed the Bridge on foot on opening day, it was discovered that the Bridge exhibited harmonic resonance, and the cable wire would vibrate to produce both harmonic and discordant notes. *San Francisco Chronicle* reporter Willis O'Brien referred to this as the "35 million–dollar steel harp."

"A man held up his hand and shouted: 'Be Quiet! Listen to the Bridge!' A hush fell on the crowd near him. They stood still—and heard the voice of the Bridge! It is a queer, unearthly sound, that voice ... Away down there is a deep road, like the bass notes of a piano. High up in the wires is a shrill sound that some violoncello might produce ... a series of different notes, changing, deepening, rising ... "

—WILLIS O'BRIEN
San Francisco Chronicle, May 27, 1937

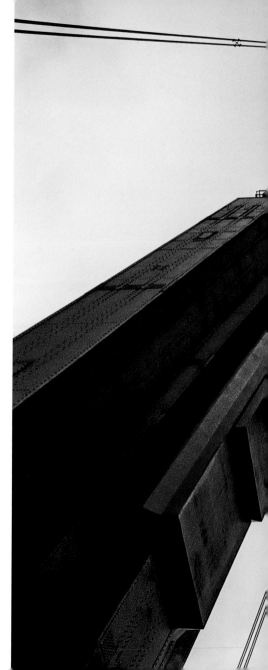

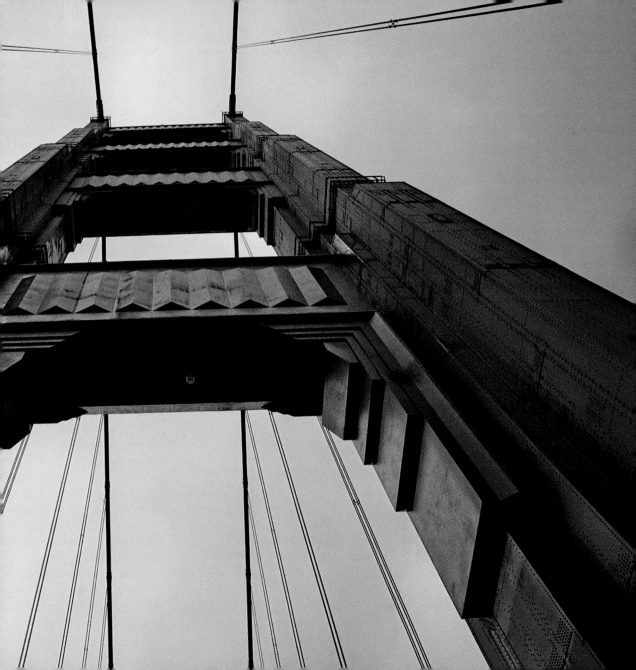

It seems that each person who experiences the
harmonic resonance of the Bridge takes away
a unique musical experience.

"THE BRIDGE CABLES

WERE BEING PLUCKED LIKE GIANT HARP STRINGS

BY THE FINGERS OF THE WIND."

• ◉ ◉ •

—NANCY KENT
remembering the windstorm of December 1, 1951

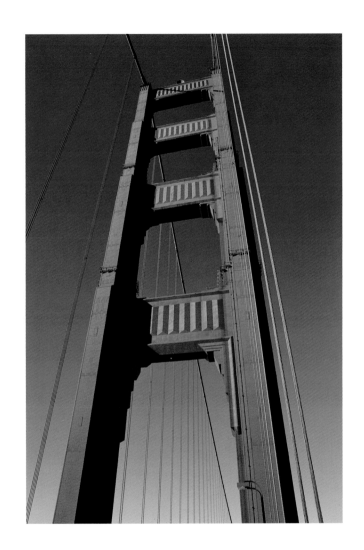

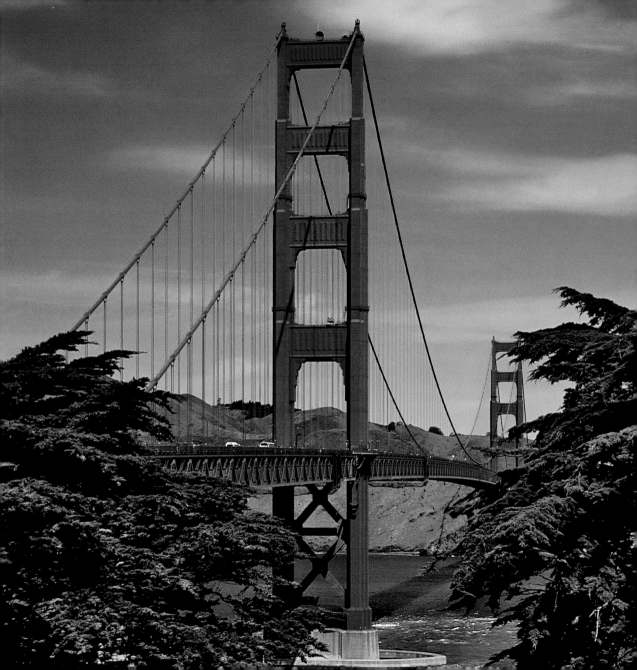

"The Bridge is a musical score, and driving over it is like

playing a quiet, rhythmic piece for the first time, every time."

—BRAD BUNNIN, Docent, *U.S.S. Potomac*, 2011

FREMONT'S GATE

BETWIXT PACIFIC AND BAY

THIS GATE SPANS OVER

GLITTERING RUSH OF SUN

ON GOLDEN WATERS' WAVE

AS EACH DAY WE CROSS

AN ACT OF DRIVEN FAITH

WHETHER SHINE OR FOG

HUNG CABLES HUMMING

TO TOWERING CRETE AND STEEL,

GLORIED CLOUDS FROM HEAVENLY

BLUED SKY OVER SUSPENDED PORTAL

TAKE US TO WHEREVER OUR THERE

MAY BE

—GERD STERN, Poet, multimedia artist, 2011

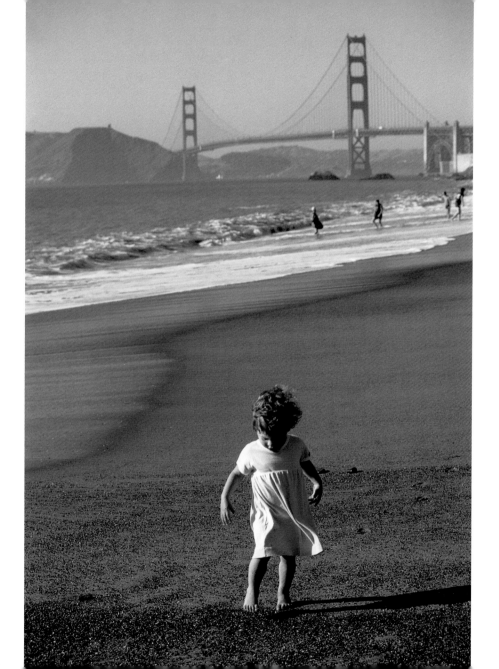

The first example of a rainbow used as a metaphor in connection with the Bridge showed up a full thirteen years before it opened.

"A bridge across the Golden Gate

will be the exclamation point that calls

attention to the beauty of the scene . . .

A thing of beauty, ethereal, graceful,

a rainbow solidified and changed into

a graceful arch of steel."

—ANNIE LAURIE

San Francisco Examiner, October 29, 1924

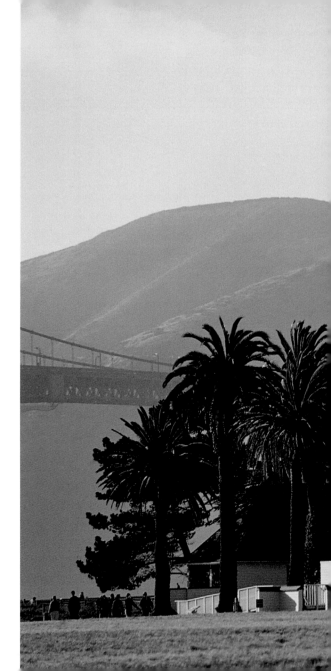

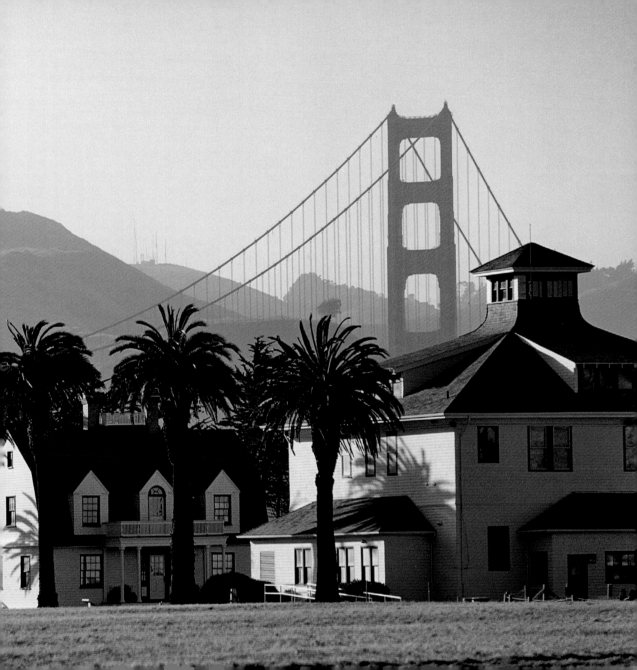

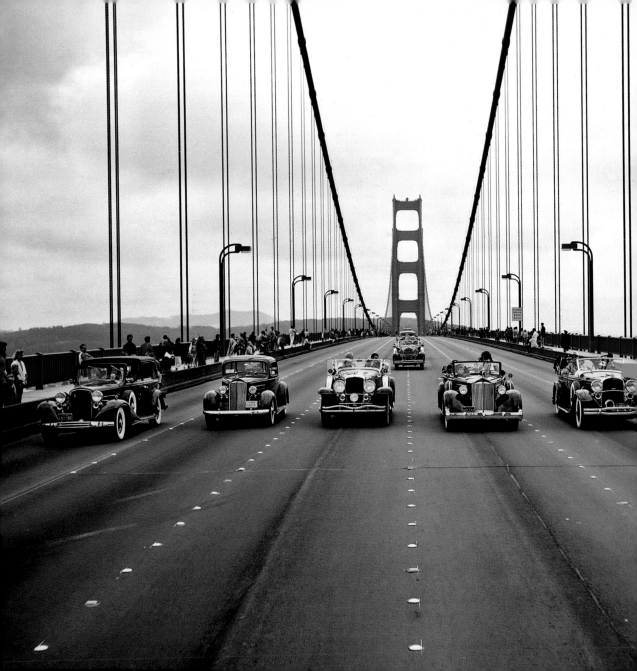

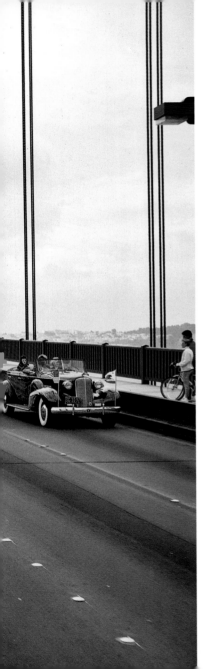

San Francisco threw a nine-day party, called the Golden Gate Fiesta, to celebrate the opening of the Bridge. The Fiesta included an opera singer, a cavalcade of historic automobiles, a fly-over of 500 airplanes, 42 ships of the U.S. Fleet, a yacht flotilla, a stampede of 100 wild horses, a Naval Ball, an Army-Navy baseball game, fireworks, beauty contests, a gold rivet, and the pedestrian walk.

"With eager expectations, San Franciscans . . . have looked forward to this day when the mighty Golden Gate Bridge would be opened to the traffic of the world. And, now that this glorious enterprise is completed, rejoicing is in every heart. To you who have come from afar, we offer hospitality beyond measure. May the Bridge be a bond, uniting us ever in the bonds of brotherhood. "

. ◉ ◉ ◉ .

—ANGELO ROSSI, Mayor of San Francisco, in the official program of the Golden Gate Bridge Fiesta, held from May 18 to May 27, 1937

The dedication ceremonies that marked the
beginning of the construction of the Bridge would
rival any grand opening today.

"While airplanes zoomed over the
heads of the massed throng on Crissy
Field, where the ceremonies were
held, dropping gloating bouquets of
rose petals on an eighty-foot replica
of the great span . . . other airplanes
threw a smoke screen across the bay
on the line the bridge will traverse
. . . the spectacle held the thousands
with bated breath at the sheer beauty
of the scene."

—Floyd J. Healy
Los Angeles Times, February 27, 1933

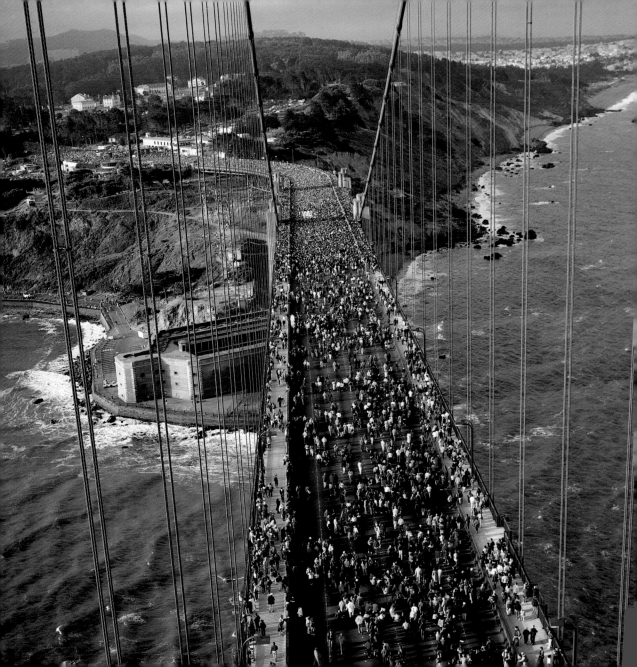

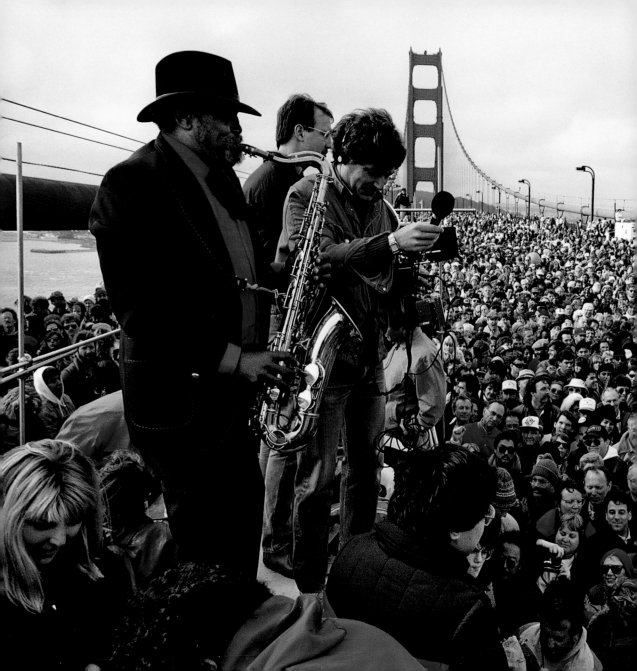

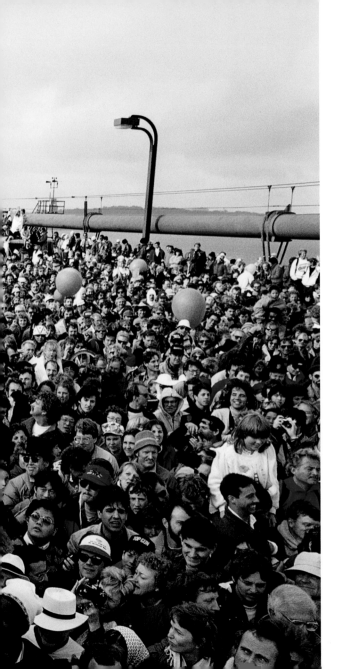

As one eyewitness reported on the irrational exuberance of opening day, more than anything else, it was a demonstration of community spirit and *joi de vivre*; a San Francisco tradition.

"The Old Town went nuts yesterday!

It stood on its head.

It walked on its hands.

It threw its hat in the air.

It made faces and danced.

It tore off its collar and barked like a dog.

It rolled over and squealed . . .

the limitless, happy-go-lucky,

insane enjoyment of the Gate opening

that swept the place."

—WILLIS O'BRIEN
San Francisco Chronicle, May 28, 1937

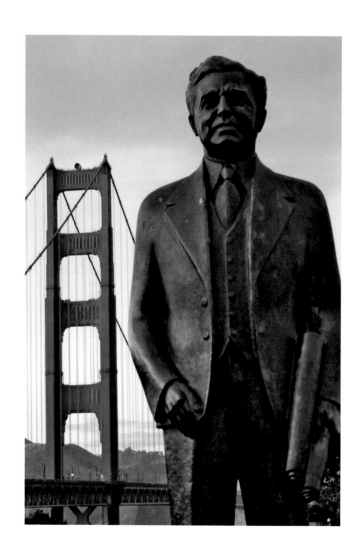

Joseph Strauss, the Chief Engineer, received the
public tribute of a statue erected in his honor
with the following inscription under the heading
"1870—Joseph B. Strauss—1938."

THE MAN WHO BUILT THE BRIDGE

HERE AT THE GOLDEN GATE IS THE

ETERNAL RAINBOW THAT HE CONCEIVED

AND SET TO FORM, A PROMISE INDEED

THAT THE RACE OF MAN SHALL

ENDURE UNTO THE AGES.

Chief Engineer of the
Golden Gate Bridge 1929–1937

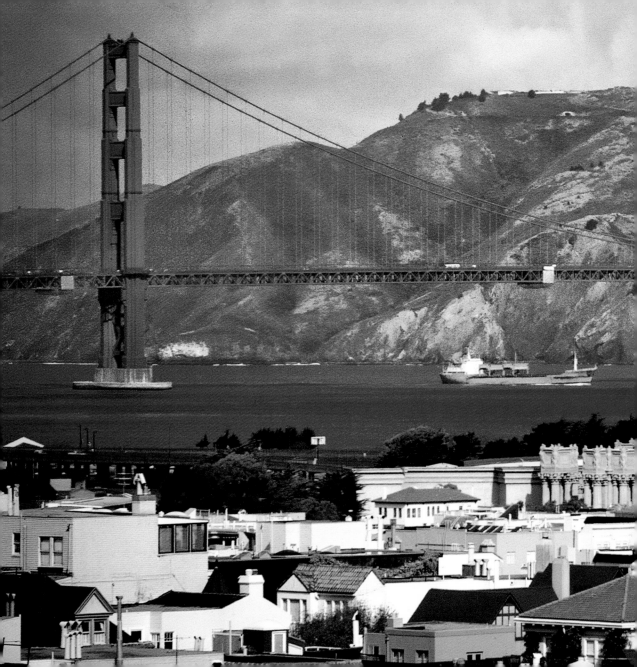

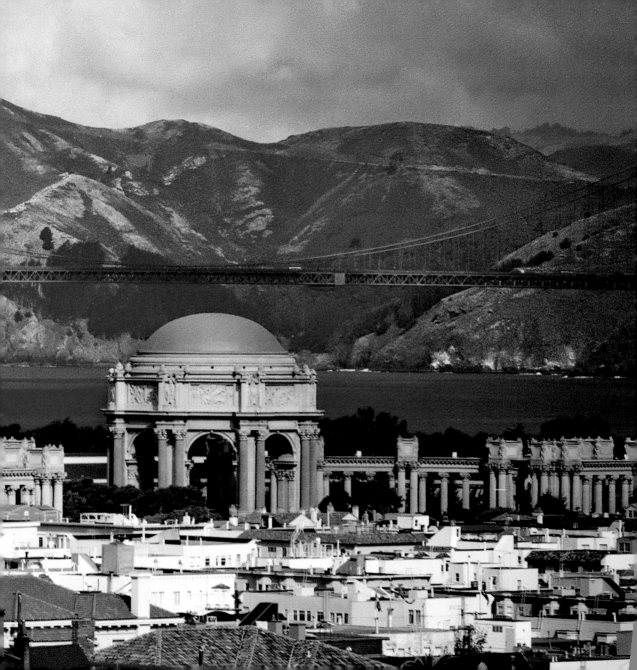

"ETERNAL RAINBOW."

———

—JOSEPH STRAUSS, Chief Engineer

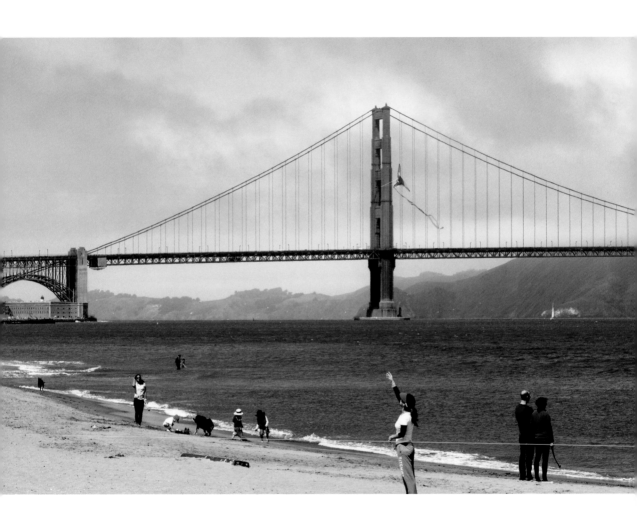

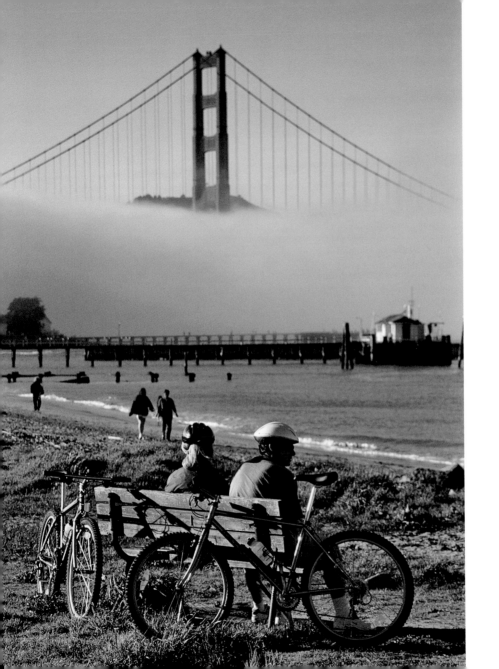

"Residents of the San Francisco Bay area

feel this bridge as an entity . . .

They admire its living grace and its magnificent setting.

They respond to its many moods—

its warm and vibrant glow in the early sun,

its seemingly play with, or disdain of, incoming fog,

its retiring shadowy form before the sunset,

its lovely appearance in its lights at night.

To its familiars it appears

as the 'Keeper of the Golden Gate.'"

———•———

—GOLDEN GATE BRIDGE
DISTRICT PUBLICATION

"IT TOOK TWO DECADES

AND TWO HUNDRED MILLION

WORDS TO CONVINCE PEOPLE

THE BRIDGE WAS FEASIBLE."

—JOSEPH STRAUSS, Chief Engineer

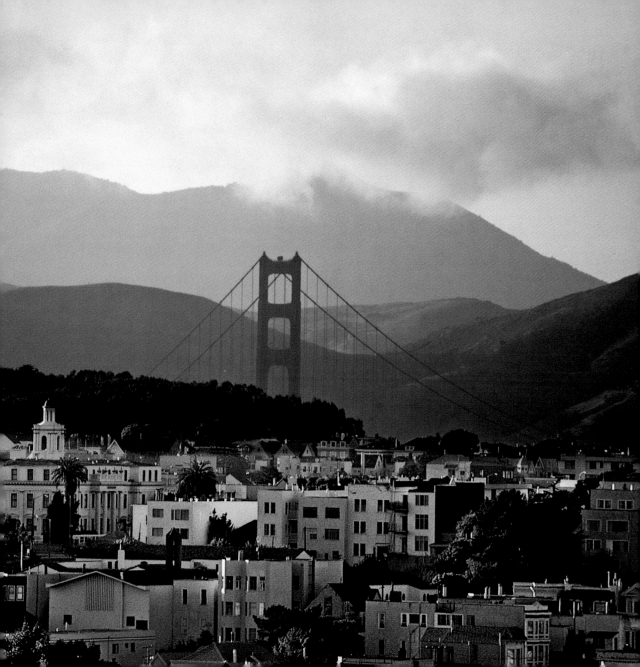

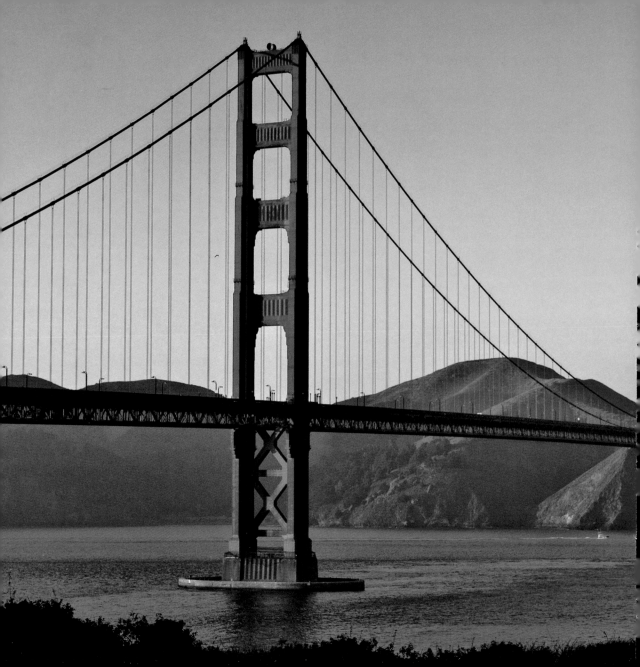

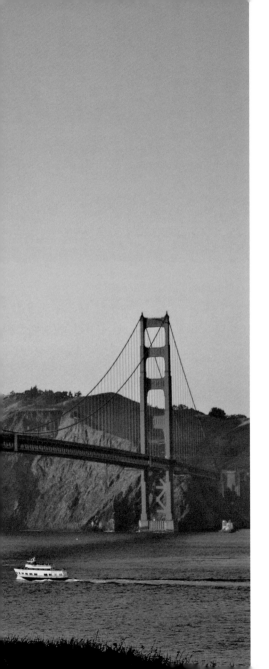

"The Golden Gate Bridge might be defined
as two architectural components—
a gate ('the point of entry to a space') and
a bridge ('a structure built to span physical obstacles')—
wrapped in a collective ('golden') fantasy.
It is a golden gate bridge not in the sense of its color
(the bridge is actually orange)
but philosophy's golden mean—
'the felicitous middle between the extremes
of excess and deficiency.'"

—L. JOHN HARRIS,
Bay Area artist, filmmaker, and author, 2011

In this speech made on the eve of World War II, the completion
of the Bridge was seen as a victory for the forces of peace in a
world awash in war and rumors of war. Peace would grow out of
reason, science, logic, and cooperative effort. These were some
of the humanistic and technocratic themes of the day.

"What nature rent asunder in the long ago,

man has now joined together, and in the joining he has

fashioned a great and powerful instrument of peace . . .

For in the domain of bridges alone, man has achieved

that state of equilibrium and teamwork which compels peace.

The mighty network of steel which constitutes the Golden Gate

Bridge is mute but eloquent evidence of the power

that resides in order, reason, and logic and reflects the heights

that can be achieved by cooperative effort and harmony."

———

—JOSEPH STRAUSS, Chief Engineer,
from the speech he delivered
at the Golden Gate Bridge Dedication Ceremony
at Crissy Field, May 28, 1937

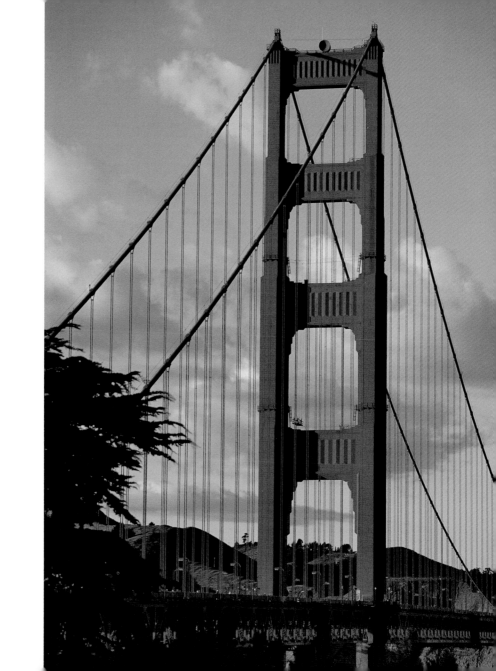

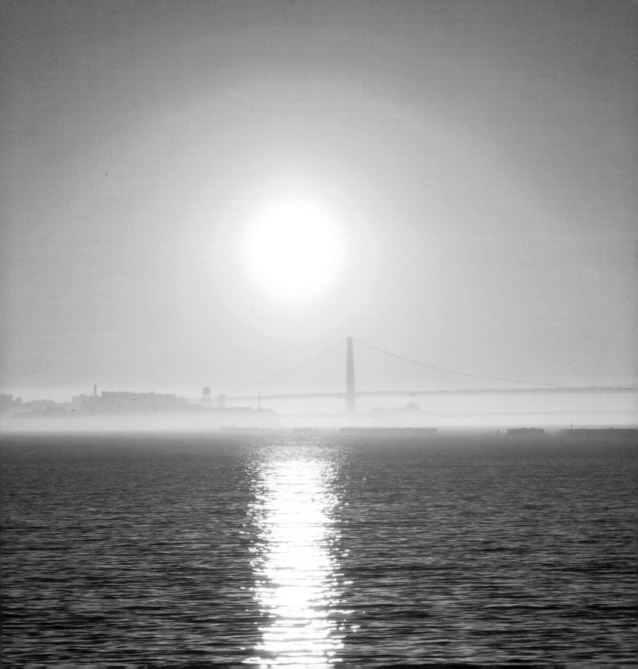

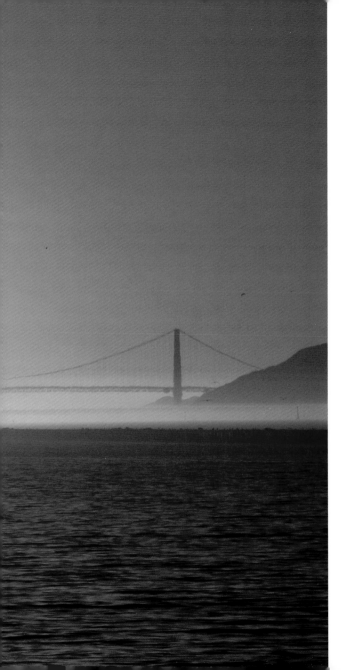

The Golden Gate Bridge inspired Joseph Strauss, its Chief Engineer, to poetry. Here is an excerpt from his poem "The Mighty Task Is Done," in which he sings the praises of the final creation:

At last the mighty task is done;

Resplendent in the western sun

The Bridge looms mountain high;

Its titan piers grip ocean floor,

Its great steel arms link shore with shore,

Its towers pierce the sky.

. . .

—JOSEPH STRAUSS, Chief Engineer,
"The Mighty Task Is Done"

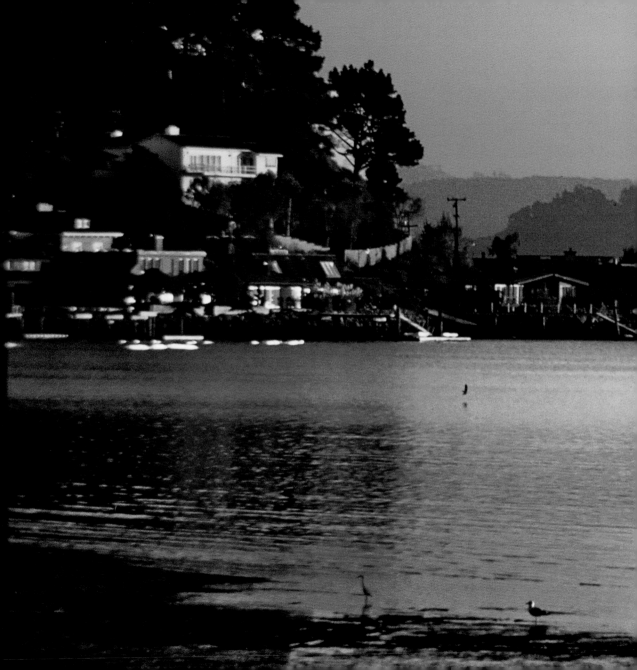

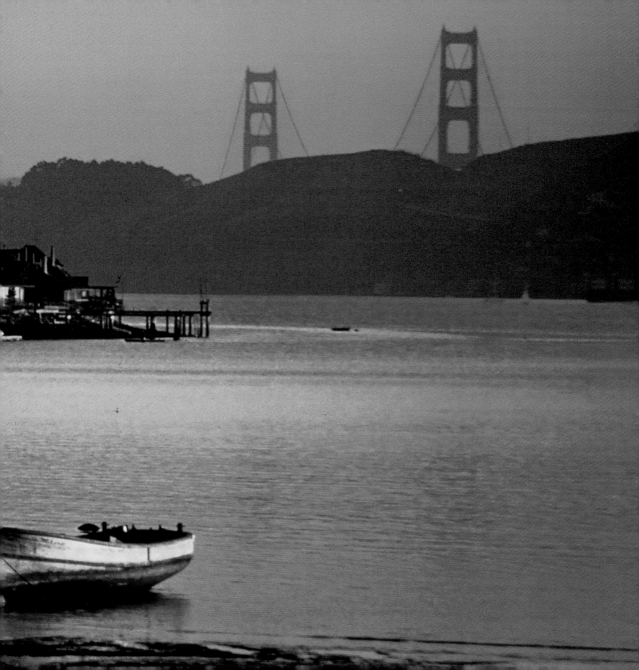

"The Golden Gate Bridge embodies a beauty at once useful and transcendent . . .

and offers enduring proof that human beings can alter the planet with reverence."

—KEVIN STARR

Golden Gate: The Life and Times of America's Greatest Bridge, 2010

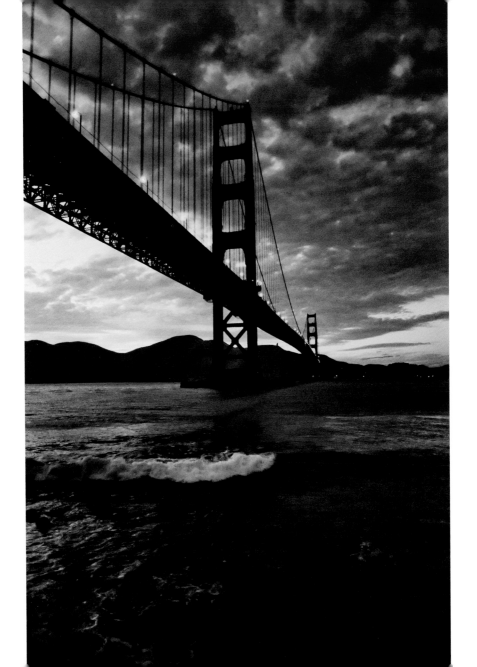

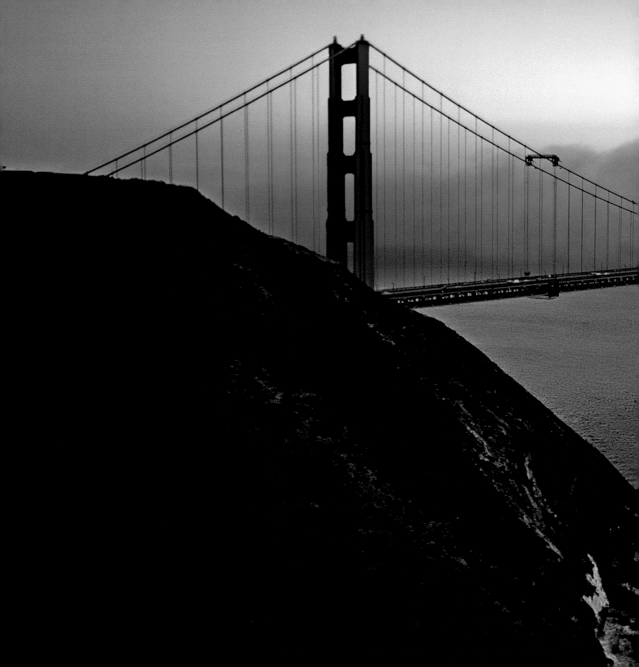

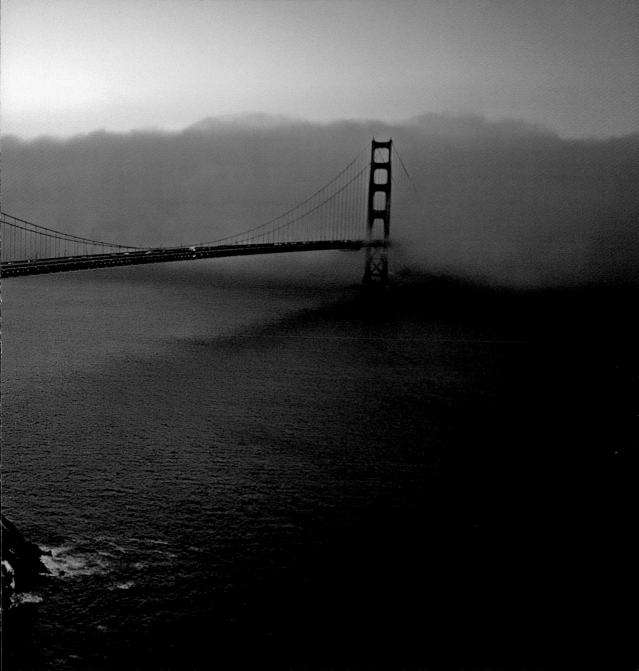

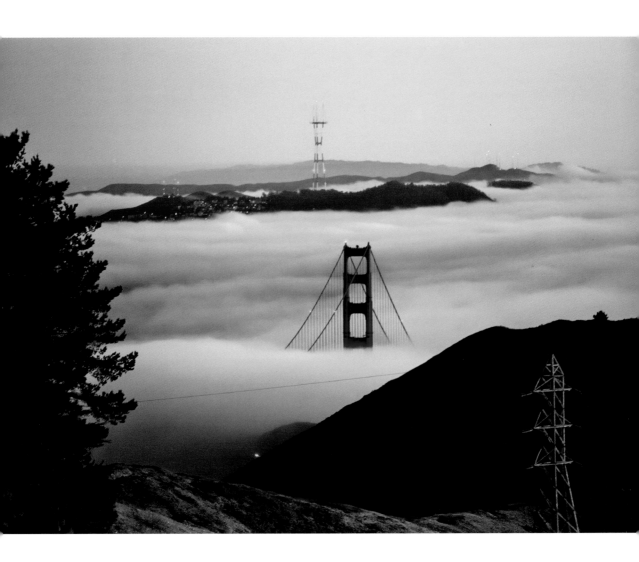

In some quarters, the Bridge represented
the coming-of-age of the West.

"Out of the thick, milk-fog of San Francisco Bay there lifts today new

towers of engineering achievement . . . Today the throne of engineering

initiative and ingenuity is on the Pacific Coast . . . With the movement west,

where a new land lay ripe for development and mammoth achievement, came

the crown of international supremacy in the arena of construction."

—KENNETH CRIST
"Come West All Engineering Genius!" *Los Angeles Times*, November 18, 1934

Prophetic in its scope, the conclusion of this passage, written ten years before Pearl Harbor, envisions a Pacific shift with the center of civilization passing from the Atlantic to the Pacific.

"The parallel latitude on which my mind's glance moves, reaches from Sausalito to Tokyo. They are just opposite each other on the shores of the vast and usually smiling sea . . . a sea about which are happening the most important developments of mankind. The Golden Gate Bridge will be a celestial dimension in a stroll . . . [it] will mark the beginning of the transfer of vision and action to the Pacific."

—FREDERICK O'BRIEN
"Golden Gate Bridge Will Allure the Eye,"
Los Angeles Times, April 8, 1931

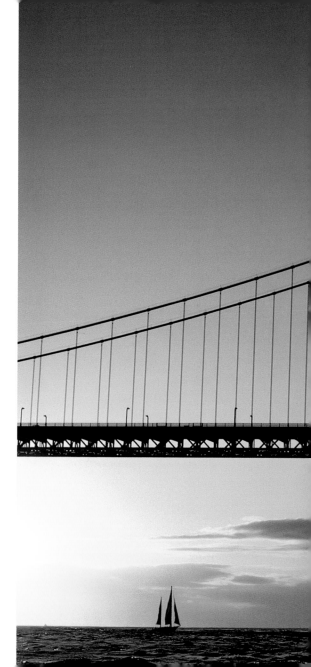

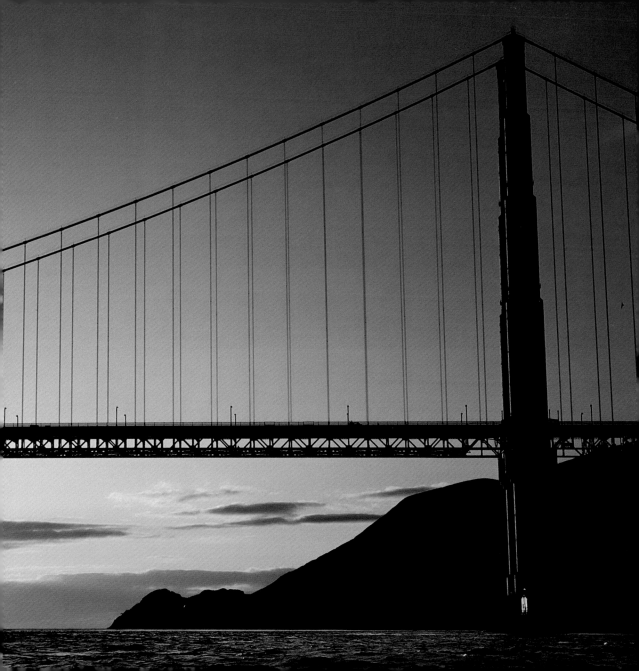

"THE MOST FAMOUS,

MOST ADMIRED,

AND CERTAINLY BEST-LOVED

BRIDGE IN THE WORLD."

———•———

—STEPHEN CASSADY
Spanning the Gate: The Golden Gate Bridge, 1986

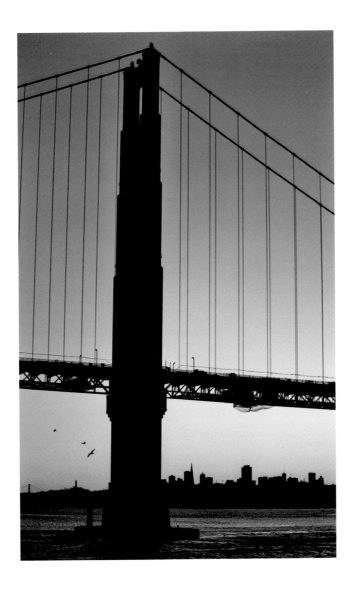

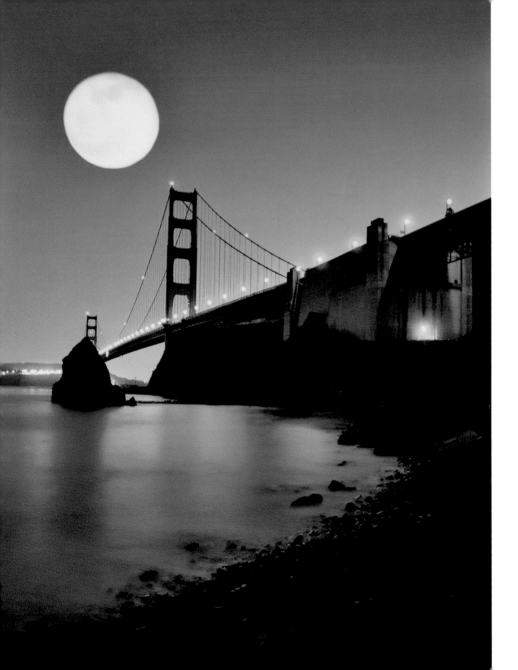

"And at night, returning by way of Sausalito

(a hotbed of clangorous, vehemently dissident individuals

with un-American beards), traveling from north to south

across the Golden Gate, you behold a dream:

there wink the vitreous topaz lights of San Francisco,

like the holy city of Byzantium."

· ❀ ❀ ·

—EVAN S. CONNELL JR.
Holiday Magazine, April, 1961

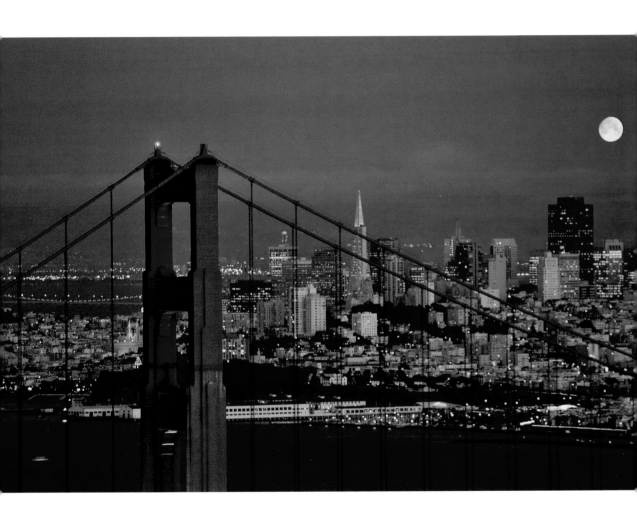

This *San Francisco Chronicle* reporter was among the first of many other writers who reached, over the decades, for the perfect way to describe the Bridge.

"A necklace of surpassing beauty was placed

about the lovely throat of San Francisco yesterday."

—WILLIS O'BRIEN
San Francisco Chronicle, May 28, 1937

"Do you believe that this magnificent

bridge was built at the Golden Gate? Nonsense!

It was built by people at the polls.

It was built in the courts.

It was built in the paneled offices of bankers.

Then, and only then, could it be built

at the Golden Gate. This bridge had

as many births as a cat has lives."

———•———

—JACK D. WRIGHT
September 6, 1963

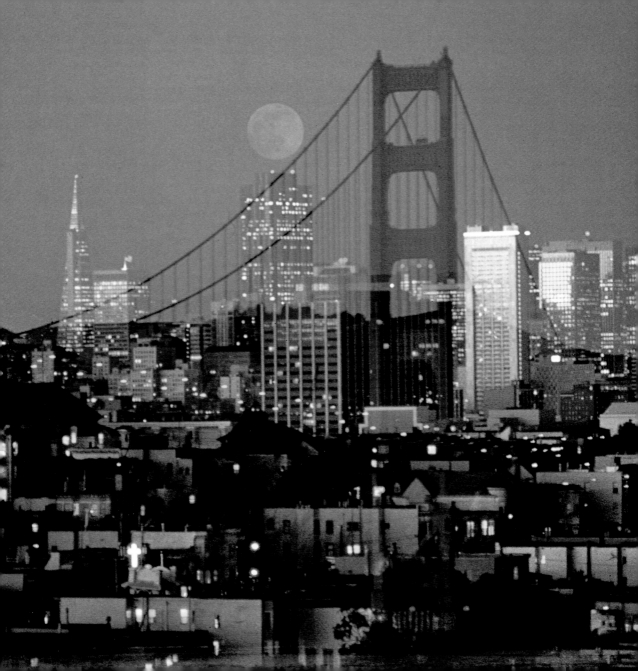

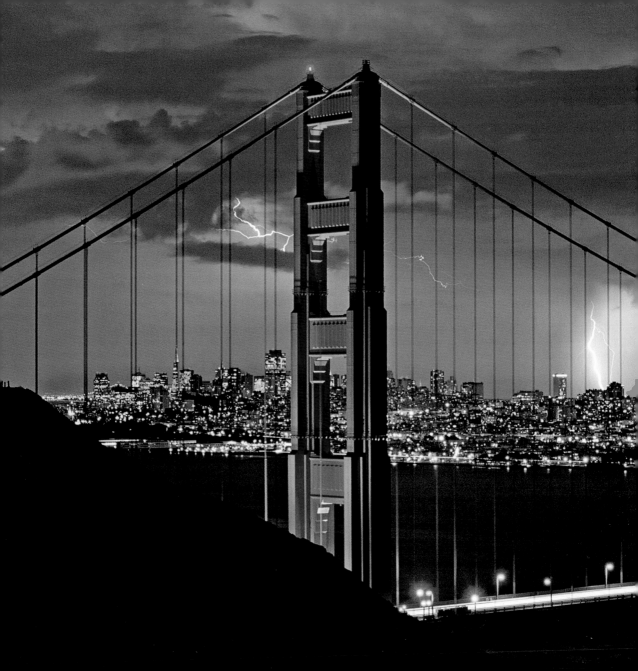

"WHEN YOU BUILD

A BRIDGE,

YOU BUILD SOMETHING

FOR ALL TIME."

——JOSEPH STRAUSS, Chief Engineer

"A WORLD ICON."

· ◉ ◉ ◉ ·

—KEVIN STARR

Golden Gate: The Life and Times of America's
Greatest Bridge, 2010

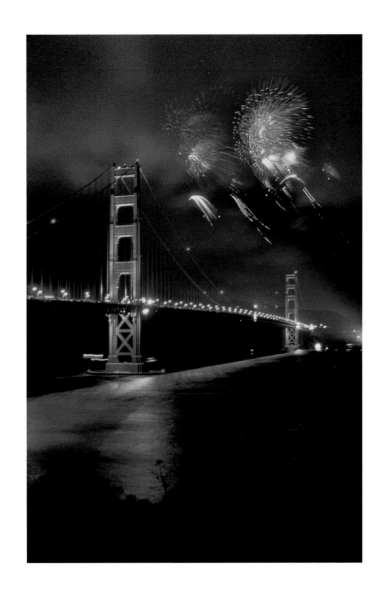

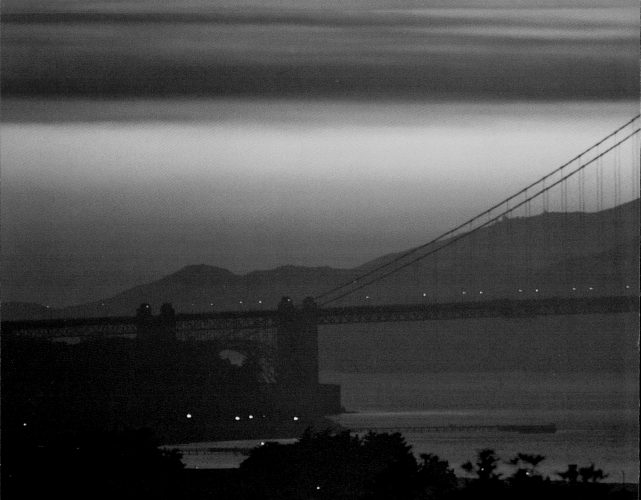

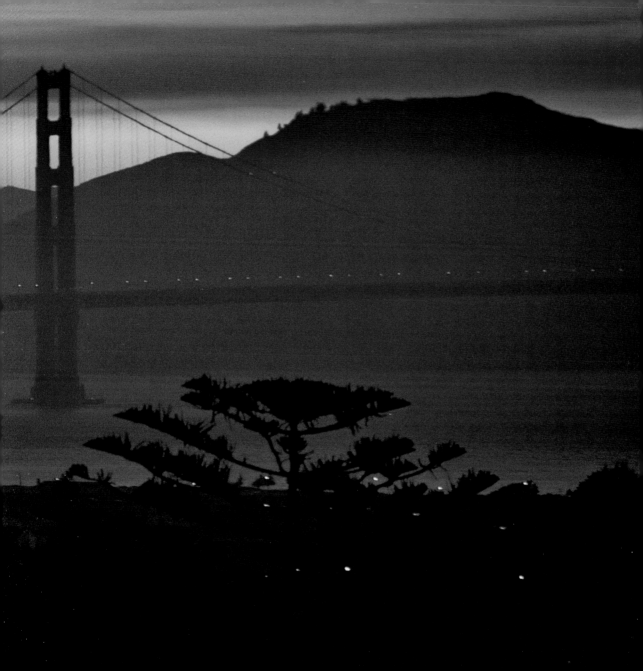

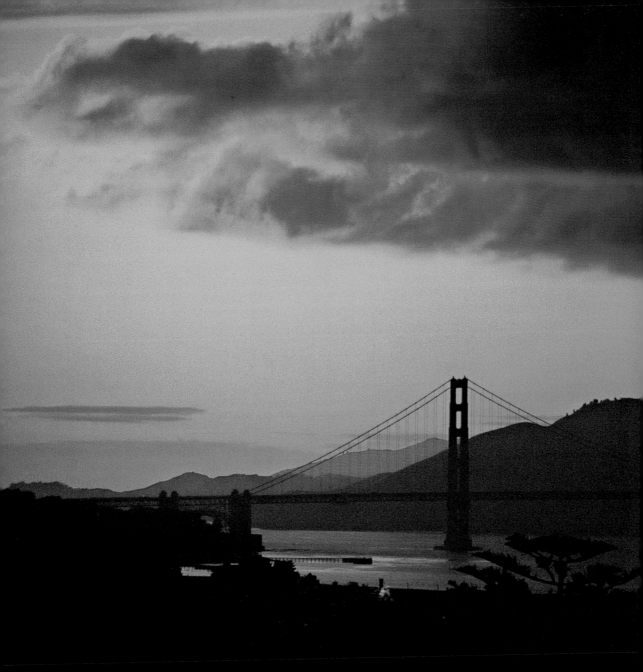

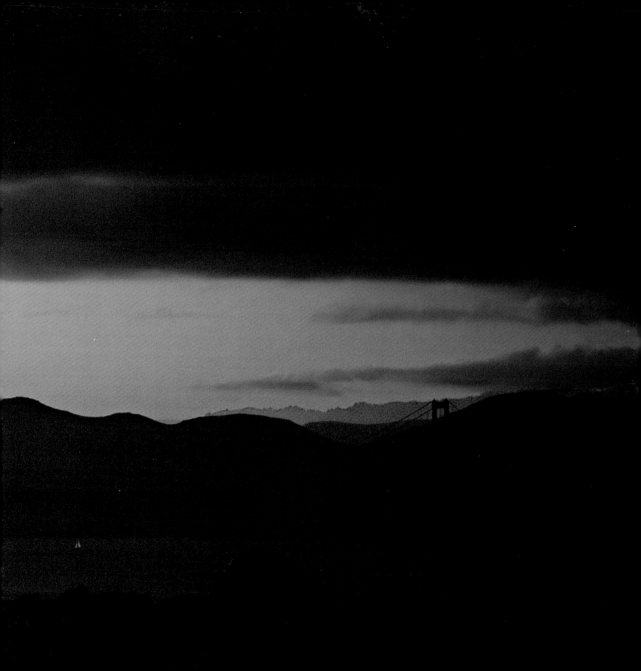

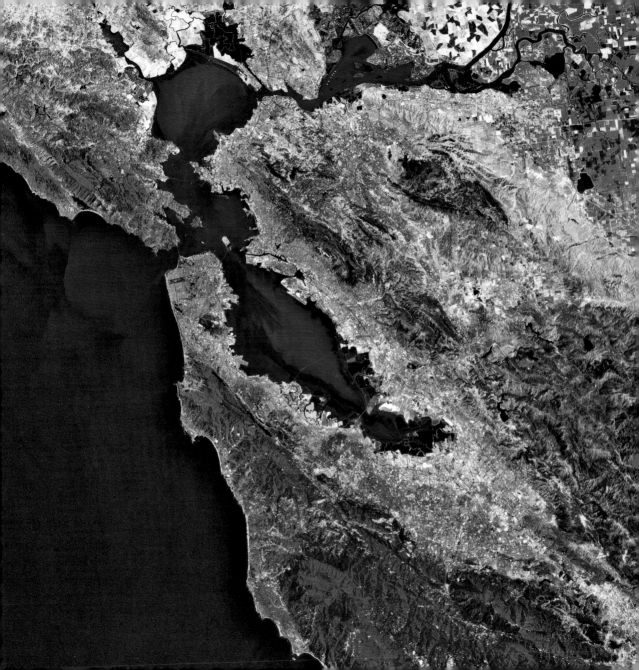

SELECTED BIBLIOGRAPHY

Brown, Allen. *Golden Gate: The Dramatic Story of the Planning, Building and Operating of the Bridge.* New York: Doubleday, 1965.

Cassady, Stephen. *Spanning the Gate: The Golden Gate Bridge.* Santa Rosa: Squarebooks Publishing, 1986.

Dillon, Richard, Thomas Moulin, and Don DeNevi. *High Steel: Building the Bridges Across San Francisco Bay.* Berkeley: Celestial Arts, 1979.

Evans, Richard Everett. *The Golden Gate.* New York: Pageant Press, 1961.

Federal Writers Project of the Works Progress Administration. *San Francisco in the 1930s: The WPA Guide to the City by the Bay.* Berkeley: University of California Press, 2011.

Federal Writers Project of the Works Progress Administration of Northern California. *Almanac for Thirty-Niners.* Stanford: Stanford University Press, 1938.

Starr, Kevin. *Golden Gate: The Life and Times of America's Greatest Bridge.* New York: Bloomsbury Press, 2010.

OPPOSITE *The San Francisco Bay Area seen from space. Even at such a distance, the Golden Gate Bridge is visible, linking the Marin Headlands and the Peninsula.*

A C K N O W L E D G M E N T S

PETER BEREN

It is a rare privilege to work on a project with a photographer as talented as Morton Beebe. And this is a special subject for him. After all, Mort has been photographing the Golden Gate Bridge for more than fifty years.

I would like to acknowledge the enormous contribution of Louise Dyable, Assistant Professor of History at Michigan Technological University, who generously shared her passion and knowledge of the Bridge with me.

I would also like to acknowledge the influence of the works of Kevin Starr, whose writing provides continual inspiration for all Californians and those who love California, spirit and place. Heartfelt thanks to my friend and former comrade-at-arms, Raoul Goff, Publisher at Insight Editions, for the opportunity to put together this book. Special thanks to Insight's gifted editor, Jake Gerli, for superb guidance. As always, I am grateful to Lena Tabori for her support. Finally, special thanks to longtime friend and former colleague, Baron Wolman, Publisher of Squarebooks, who allowed *Spanning the Gate* to be used as a source for this book, in general, and for the Joseph Strauss quotations, in particular.

MORTON BEEBE

Thank you to my wife Danielle and brothers Bob and Bruce, who drive the Golden Gate Bridge every day. I was carried over the Bridge by my parents on opening day in 1937 and have been photographing it since 1952.